BLACK IMAGES

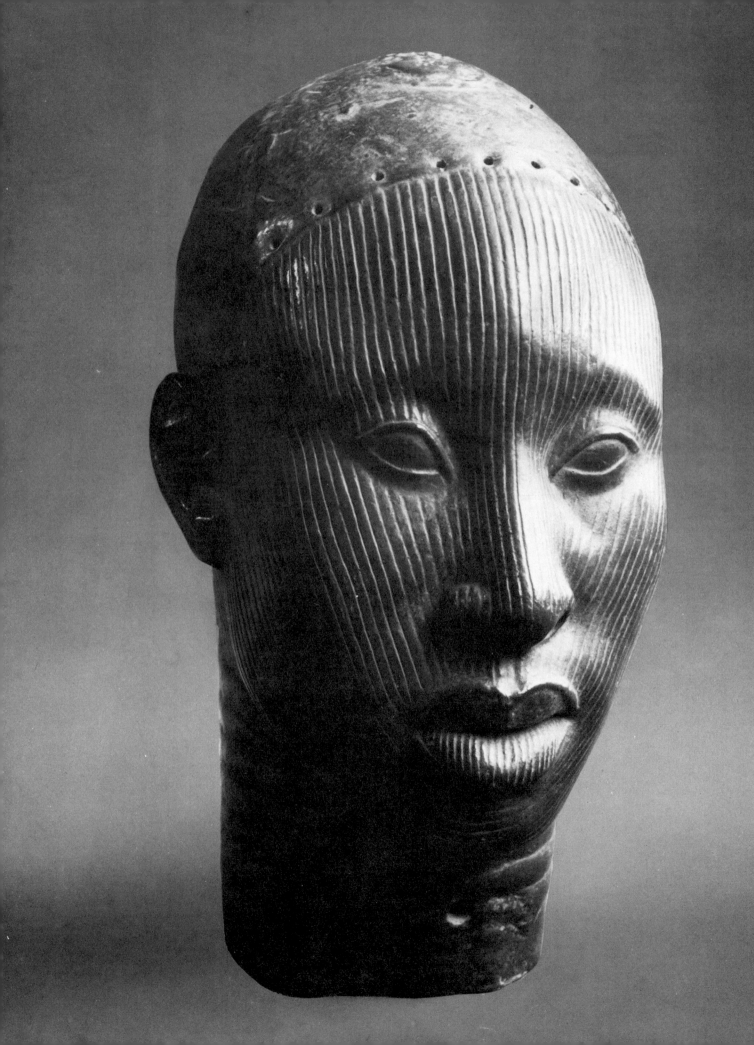

BLACK IMAGES

THE ART OF WEST AFRICA

BY PENELOPE NAYLOR WITH PHOTOGRAPHS BY LISA LITTLE

DOUBLEDAY & COMPANY, INC., GARDEN CITY, NEW YORK

ISBN: trade 0-385-06025-4
ISBN: prebound 0-385-07462-x
Library of Congress Catalog Card Number 72-92233
Copyright © 1973 by Penelope Naylor Da Costa Leite
All Rights Reserved
Printed in the United States of America
First Edition

Designed by M. F. Gazze

The author wishes to thank Dorothy Lytle, Allan Chapman and Ellen Gleason of The Museum of Primitive Art, New York, for their thoughtfulness, patience and advice.

Grateful acknowledgment is made to The Museum of Primitive Art, New York, The Metropolitan Museum of Art, New York, and The Paul Tishman Collection, New York, for permission to reproduce works of art from their collections.

The sculptures photographed in this volume are all courtesy of The Museum of Primitive Art, New York, with the exceptions of: Yoruba Dish with Mother and Child (p. 12), courtesy of The Metropolitan Museum of Art, Rogers Fund, 1971; Brass Figure of Gu (p. 72), courtesy of The Paul Tishman Collection, New York; Copper Mask (p. 56) and two Brass Heads (pp. 2 and 58), which are British Museum casts of the original sculptures from the Ife Museum, Nigeria.

The Ashanti Kente Cloth reproduced on the endpapers is courtesy of The Museum of Primitive Art, New York. Drawing for part titles: symbolic sword, iron, Ashanti, Ghana. Title page: head, brass (cast), Court of Ife, Yoruba, Nigeria, VIII-XI centuries. Opposite page: fetish figure, wood, cloth, feathers and other materials, Senufo, Ivory Coast.

Grateful acknowledgment is made for permission to reprint the following poems, listed in the order in which they appear in the book. Every effort was made to contact copyright owners, and if any omissions have occurred, they are inadvertent.

p. 13 "Oshun the River Goddess," from YORUBA POETRY by Bakare Gbadamosi and Ulli Beier, The Ministry of Education, Ibadan, 1959.

p. 15 "Song by a Woman Giving Birth," translated by Willard R. Trask, from L'ÂME DU PYGMÉE D'AFRIQUE by H. Trilles, Les Éditions du Cerf, Paris, 1945.

p. 19 "Praise—Names of Twins," from THE MOON CANNOT FIGHT, Mbari, Ibadan.

p. 23 "The Wandering Story-Teller," translated by Willard R. Trask, from Hans Himmelheber, AURU POKU: MYTHEN, TIERGE-SCHICHTEN UND SAGEN, SPRICHWÖRTER FABELN UND RÄTSEL ("Das Gesicht der Völker," Westafrikanisher Kultur-kreis, Dichtung der Baule), Eisenach, Erich Roth Verlag, 1951, p. 7.

p. 27 "Chant for Girls During Puberty Ceremony," from ANTS WILL NOT EAT YOUR FINGERS by Leonard Doob, New York, 1966, Copyright © 1966 by Leonard W. Doob; reprinted by permission of the publishers, Walker & Co., Inc.

p. 29 "Love Song" (Bagirmi), from ESSAI DE GRAMMAIRE DE LA LANGUE BAGUIRMIENNE by H. Gaden, Paris.

p. 34 "Memory," from YORUBA POETRY, compiled and edited by Ulli Beier, Cambridge University Press, Cambridge, 1970.

p. 38 "Drum Call," from ORAL LITERATURE IN AFRICA by Ruth Finnegan, Clarendon Press, Oxford, 1970; original source: TALKING DRUMS OF AFRICA by J. F. Carrington, London, 1949.

p. 38 "Mugala's Song," translated by Willard R. Trask, from CLASSIC BLACK AFRICAN POEMS, selected and edited by Willard R. Trask, The Eakins Press, New York, 1971.

p. 43 "Python," from IJALA, Papua Pocket Poets, Port Moresby.

p. 45 "Chi Wara Song," from AFRICAN ARTS, Volume IV, Number 1, "The Dance of the Tyi Wara" by Dr. Pascal James Imperato, Los Angeles, 1970.

p. 49 "Buffalo," from IJALA, Papua Pocket Poets, op. cit.

p. 53 "Proverb," from ORAL LITERATURE IN AFRICA by Ruth Finnegan, op. cit.; original source: THE CONTENT AND FORM OF THE YORUBA IJALA by S. A. Babaloa, 1966, by permission of the Clarendon Press, Oxford.

p. 57 "The King of Oyo," from YORUBA POETRY by Bakare Gbadamosi and Ulli Beier, op. cit.

p. 64 "The Oba of Benin," by John Bradbury, NIGERIA MAGAZINE, Lagos.

p. 67 "Leopard" from IJALA, Papua Pocket Poets, op. cit.

p. 69 "Ashanti Poem to Departed Rulers," from AFRICAN WORLDS, edited by Daryll Forde, "The Ashanti" by K. A. Busia, Inter-national African Institute, Oxford University Press, London, 1954.

p. 73 "Oriki Ogun," from YORUBA POETRY by Bakare Gbadamosi and Ulli Beier, op. cit.

p. 75 "May the leopard coming from the forest . . ." "Bakongo In-cantations and Prayers" by J. van Wing, London, 1930. Permis-sion of the Royal Anthropological Institute.

p. 77 "Drum Poem #7," from TECHNICIANS OF THE SACRED, edited with commentaries by Jerome Rothenberg, Double-day & Company, Inc., Garden City, N.Y., 1968, adapted by Ben Moses; original source: ASHANTI by R. S. Rattray, 1923, by permission of The Clarendon Press, Oxford.

p. 81 "Death Song," reprinted with permission of the Macmillan Company from THE UNWRITTEN SONG, VOLUME ONE by Willard R. Trask. Copyright © 1966 by Willard R. Trask.

p. 82 "Death," from JEUNE AFRIQUE, Presse Africaine Associée, Paris.

p. 85 "Funeral Song IV," from YORUBA POETRY by Ulli Beier, op. cit.

p. 86 "Dirge for Royal Ancestor," from ORAL LITERATURE IN AFRICA by Ruth Finnegan, op. cit.; original source: FUNERAL DIRGES OF THE AKAN PEOPLE by J. H. Nketia, Achimota, 1955.

p. 90 "The Will-o'-the-Wisp," translated by Willard R. Trask, from CLASSIC BLACK AFRICAN POEMS, op. cit.

p. 95 "Oracle xv," from YORUBA POETRY by Ulli Beier, op. cit.

for
Can Themba
in memoriam

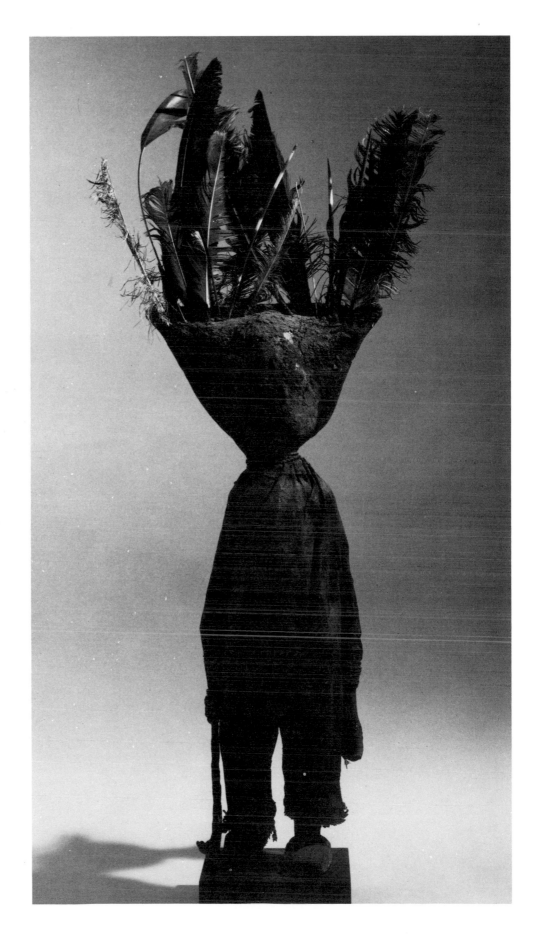

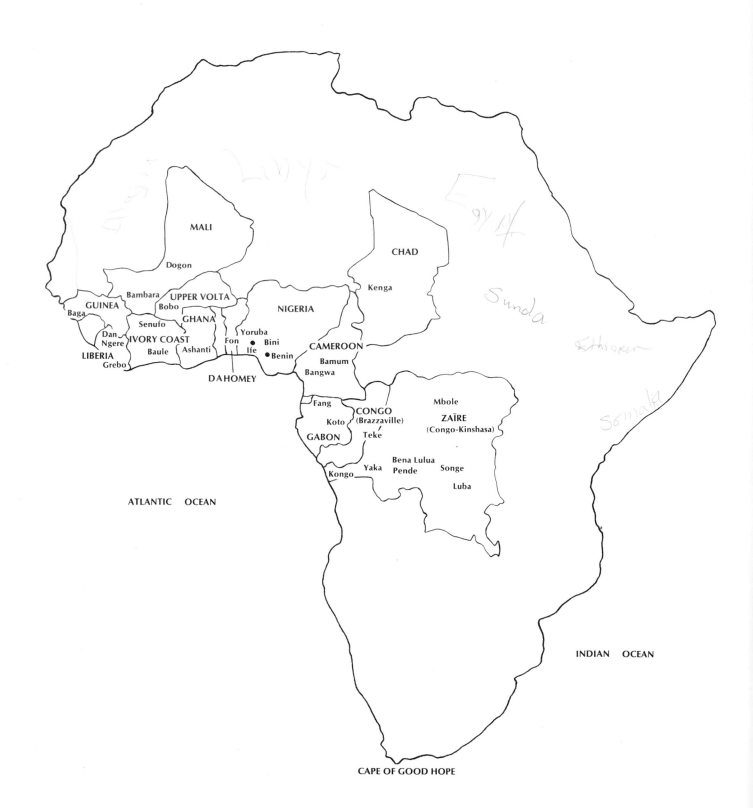

MALI

Dogon

CHAD

Kenga

GUINEA

Bambara

UPPER VOLTA

Bobo

NIGERIA

Baga

Senufo

GHANA

CAMEROON

Dan
Ngere

IVORY COAST

Yoruba

Bini

LIBERIA

Baule

Ashanti

Fon

Ife

Benin

Bamum

Grebo

DAHOMEY

Bangwa

Fang

Mbole

CONGO
(Brazzaville)

ZAÏRE
(Congo-Kinshasa)

Koto

GABON

Teke

Bena Lulua
Pende

Songe

Kongo

Yaka

Luba

ATLANTIC OCEAN

INDIAN OCEAN

CAPE OF GOOD HOPE

CONTENTS

INTRODUCTION

South of the Sahara Desert to the Cape of Good Hope stretches the vast expanse of Black Africa. There, many people live in tribal communities, pursuing agricultural and pastoral ways of life. Although they have no written languages, the people of each tribe keep their traditions alive in songs, myths, rituals, and prayers that are passed down from generation to generation. Many Africans, especially those from the forests and grasslands of West Africa, also sculpt images of gods and spirits to express and perpetuate their religious ideas.

In their traditional religions, most Africans believe that the universal God of Creation inbued the world with a sacred energy, or life-force, which animates all things. The greatest energy was given to the Creator's sons, the gods of nature, and after them, to the primeval ancestors of the tribe. In its proper state, this energy keeps the world in harmonious order, but at times, men's evil deeds, or the activities of demons and witches, cause the rhythm of life to be destroyed. Natural disasters, sickness, and untimely deaths then occur to threaten the stability of the world. To correct the disorder, new life-force must be generated by the tribe to increase the power of the spirits. By performing ceremonies, and offering sacrifice and prayers, the tribe helps the gods and ancestors to overcome the evil forces, so that harmony and peace are restored.

Religion is an integral part of the traditional Africans' lives, inseparable from the events of each day. Sculptures, in turn, serve the vital and continuous function of bringing the forces of the world within man's control. When religious ceremonies are performed, each tribe employs masks, figures, and other objects, carved mainly from wood, to invoke the presence of the ancestors and gods. The spirits are summoned to dwell within the images, and to participate in the rites.

Most figures are carried or displayed during the ceremonies, or they are placed on altars or shrines. When not in use, they are often kept hidden in guarded huts or in sacred groves. The masks, which are worn as face masks, headdresses, or over the head like helmets, are used in ritual dances with costumes of fiber or leaves attached to small holes in the sides. The person wearing the mask becomes a receptacle for the indwelling spirit, and temporarily loses his own personality. His identity is completely concealed by the costume, thus encouraging belief in the spirit's presence.

As the Africans do not separate their beliefs from their daily existence, they call upon the spirits residing in the sculptures during every phase of their lives. Images of ancestors watch over mothers and children, and guide boys and girls through initiation into adulthood. Masks and figures representing the spirits of nature are used at planting time, when the first fruits appear, and in harvest celebrations. Stools, staffs,

and cups are employed in secret society and kingship rituals as emblems of authority. Other images ward off witches, invoke the spirits of war, and guard the graves of people who have recently died.

These masks, figures, and other ritual objects are not just temporary abodes for the spirits. The sculptures are links between man and the realm of the supernatural, possessing awesome powers of their own.

African sculptures express the beliefs of the entire tribe, but they are the creations of individual artists. When a mask or figure has worn away from repeated use, or if white ants have devoured the wood, a man well known for his ability as a sculptor is commissioned to carve another. Most artists work in the traditional style of their tribe, although sometimes a carver will establish a new tradition by making bold innovations of his own. The artists of each tribe usually have other professions than woodcarving, and because they do not "sign" their sculptures, their names are seldom known to outsiders. Within their communities, however, their talents are in great demand, and they are honored and rewarded for their work.

African wood sculptures do not usually last for more than one or two generations. Hence, little is known about the development of most tribal art styles. But in several West African kingdoms, sculptures were cast in bronze hundreds of years ago, and they have survived from the time of the earlier Black African civilizations. In the Yoruba kingdom of Ife, in what is now Nigeria, bronze sculptures were produced as early as the eighth century, seven hundred years before the first European explorer arrived. In later centuries, bronze was used in the Bini kingdom of Benin in Nigeria, and in the Ivory Coast, Dahomey and Ghana.

Because their stylistic development is known, the bronze sculptures of the African kingdoms can be presented in a historical manner. But the wooden sculptures of the less centralized tribes can only be discussed in the present tense, as the latest examples of an ancient, but unrecorded, tradition.

In their sculptures, the people of Black Africa have made an invaluable contribution to the artistic heritage of man. The bold forms and abstract simplicity of their masks and figures are beautiful in their own right, and they have also shown many western people a new way of looking at and understanding the visible world. Hopefully the Africans will continue to express their genius for sculpture as their beliefs and way of life change to meet the demands of the modern age.

For the moment, it must be remembered that the sculptures shown on the following pages, as well as the African poems quoted in the text, should really be seen and heard in their original settings—accompanied by ritual, dancing and song. But even detached from the rich context for which they were created, both the poems and the sculptures are still filled with energy and grace. They remain dynamically and meaningfully alive.

THE TOUCH OF A CHILD'S HAND

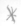
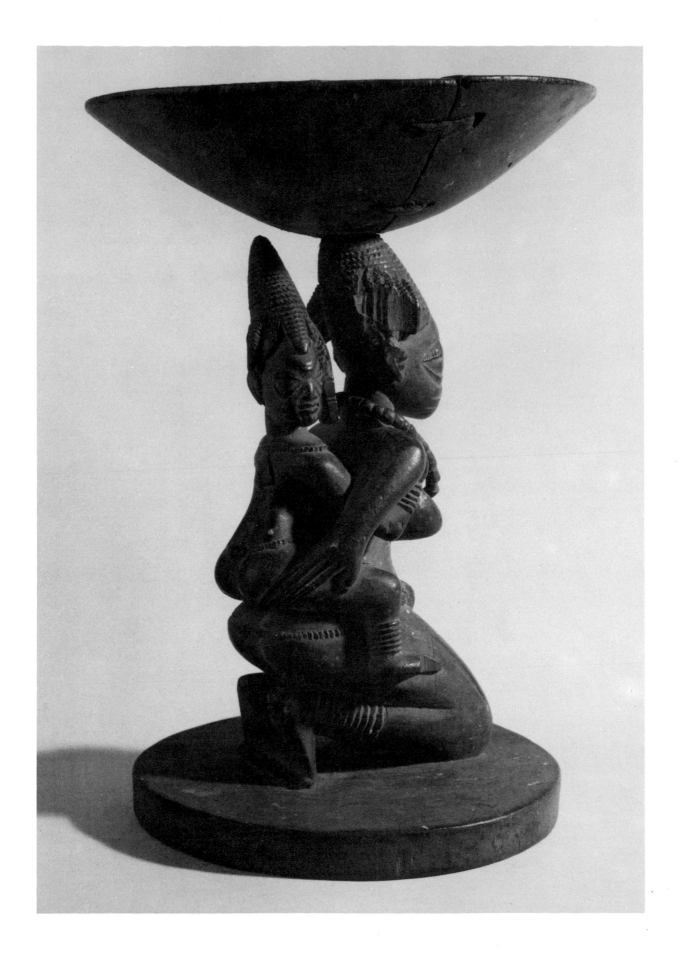

Brass and parrot feathers
on a velvet skin.
White cowrie shells
on black buttocks.
Her eyes sparkle in the forest,
like the sun on the river.
She is the wisdom of the forest
she is the wisdom of the river.
Where the doctor failed
she cures with fresh water.
Where medicine is impotent
she cures with cool water.
She cures the child
and does not charge the father.
She feeds the barren woman with honey
and her dry body swells up
like a juicy palm fruit.
Oh, how sweet
is the touch of a child's hand!

Poem to the River Goddess
Yoruba, Nigeria

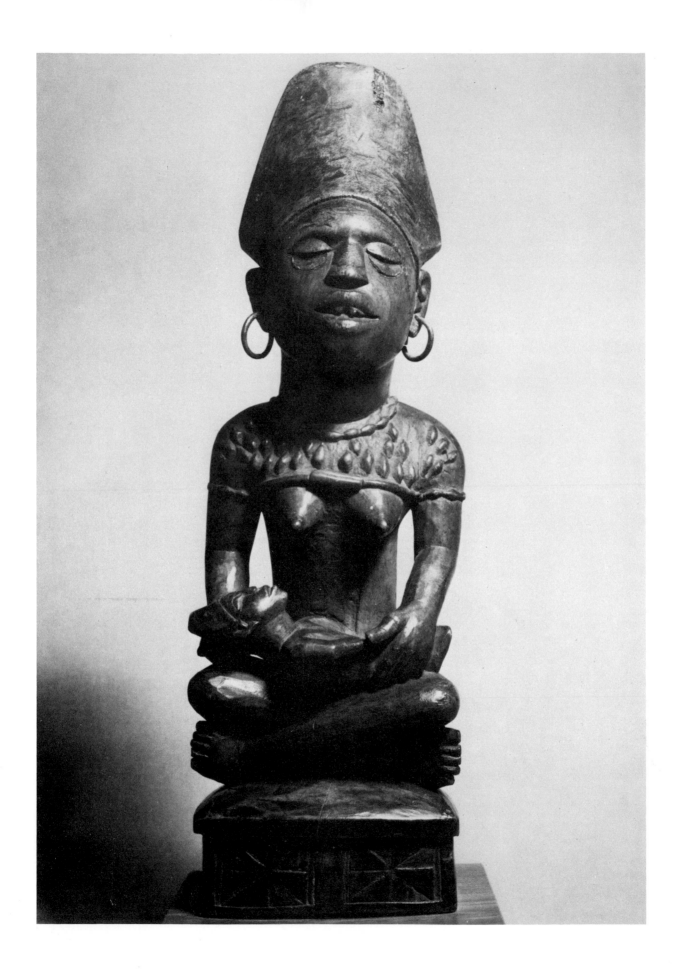

MOTHER AND CHILD ANCESTOR FIGURE
Wood
Kongo, Zaïre (former Belgian Congo)

My heart is joyful,
My heart flies away, singing,
Under the trees of the forest,
Forest our home and our mother,
In my net I have caught
A little bird.
My heart is caught in the net,
In the net with the bird.

Song by a Woman Giving Birth
Pygmy, Cameroon and Gabon

A mother with her child is a universal symbol of increase. She embodies the idea of renewal on which the continuation of all life depends. Through her ability to conceive and bear children, the destructive forces are overcome, and the harmony of the world is maintained.

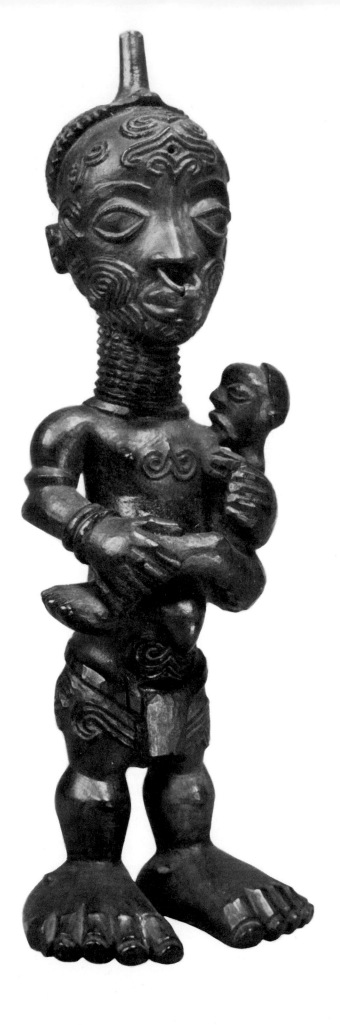

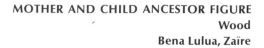

MOTHER AND CHILD ANCESTOR FIGURE
Wood
Bena Lulua, Zaïre

To express the idea of renewal, African mother and child figures often honor the tribal ancestors, as the ancestors are trusted guardians who ensure the tribe's prosperity and growth. The ancestors' spirits dwell within the figures, maintaining continuous communion with the living. At times they are asked to give their special aid to mothers and the newly born.

MEDICINE FETISH FIGURE
Wood, shells, fiber, metal
Songe, Zaïre

This fetish once carried medicines in the horn on its head. It may have been used to cure stomach ailments, although its exact function is not known. Fetishes are used for other purposes than curing sickness. They ward off witches, bring prosperity, and provide protection against dangers of all kinds.

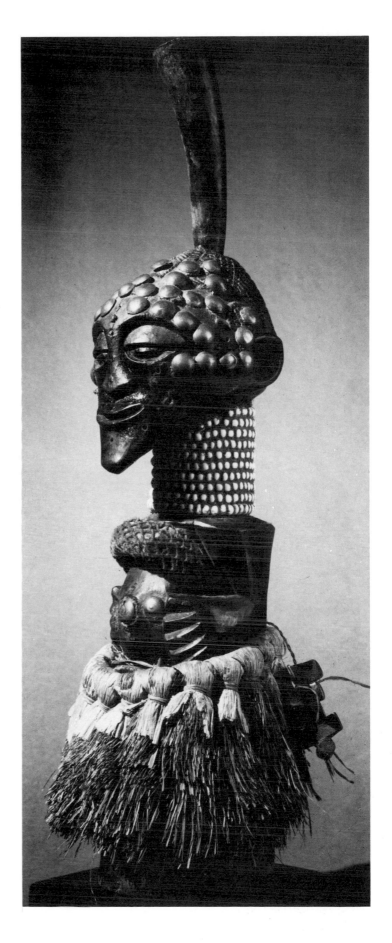

When a child is ill, a fetish figure is sometimes placed beside him to rid his body of the evil forces that are causing the disease. The fetish is supplied with magical materials and medicines that activate the powers of the spirit in the figure. Once activated, the spirit fights against the evil forces until they are driven out and health is finally restored.

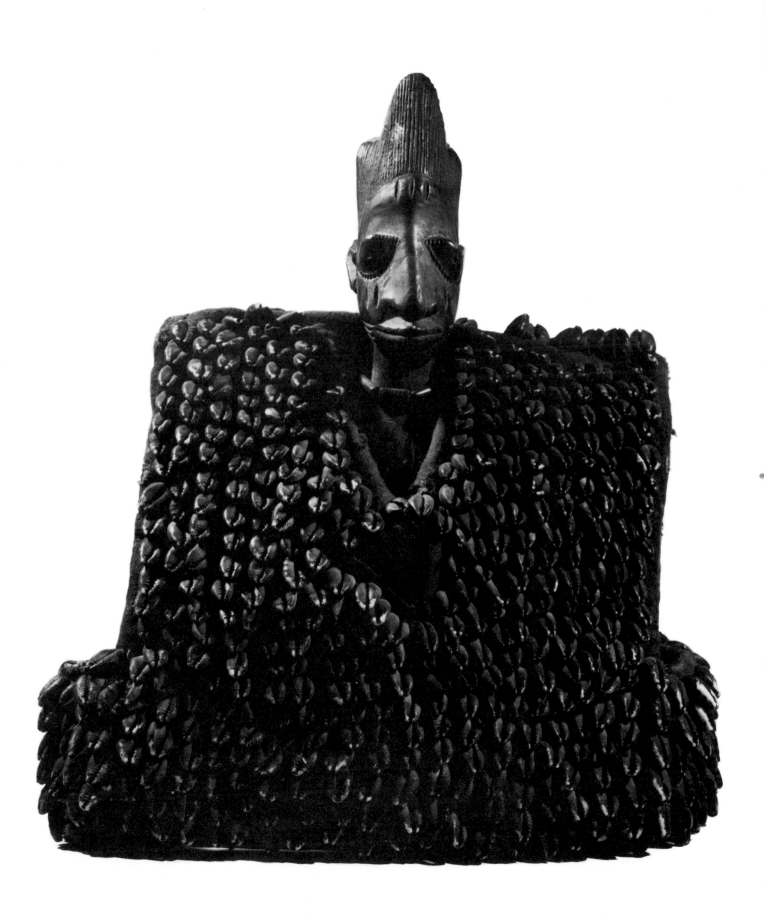

TWIN FIGURE Ibeja
Wood, cloth, cowrie shells, beads
Yoruba, Nigeria

Those who are woken up with a drum.
Those who have beautiful eyes.
I am glad to receive you.
You meet the one who prepared cloth for you.
Two in a day!

Uncountable in the eyes of the co-wives,
Though only two in the eyes of the mother,
They walk together.
They do not leave one another behind . . .

Praise-Names of Twins
Yoruba, Nigeria

In parts of Africa, the birth of twins is a bad omen, but among the Yoruba people of Nigeria, twins are prized. The Yoruba believe that the souls of the twins are united, and that they cannot be separated even if one twin should die. To keep the soul of the dead twin close to its living brother or sister, a twin figure, or ibeja, is carved.

The living twin carries the ibeja with him for the rest of his life so it can share in his daily activities. The ibeja is fed when he is fed. It is washed, anointed with oils, and dressed in tiny clothes. In every way, it is treated just like the surviving twin, because the soul of the dead twin dwells within the wooden form.

LUTE AND DRUM

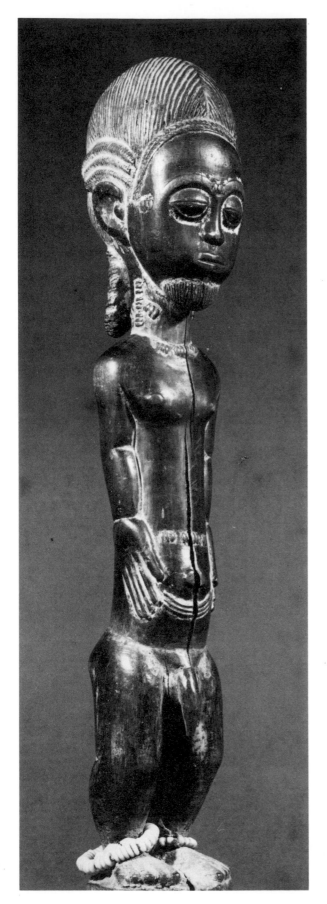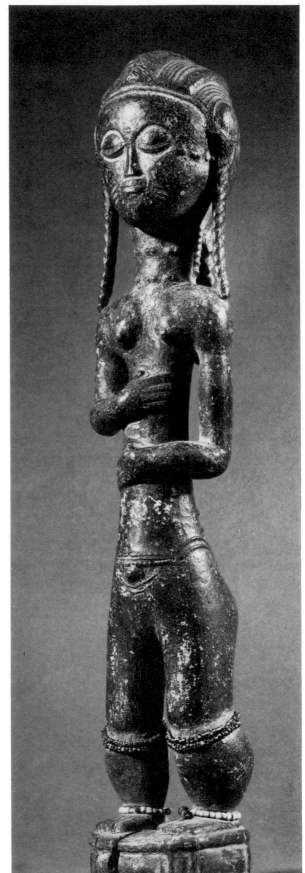

Wood, beads
Baule, Ivory Coast

In times past lute and drum
were played together for dancing.
Now only I can play the lute to my story-telling.
I am a young man,
my lute is beautiful,
because of my lute I have planted no crop,
because of my lute I have nothing to eat.

Baule, Ivory Coast

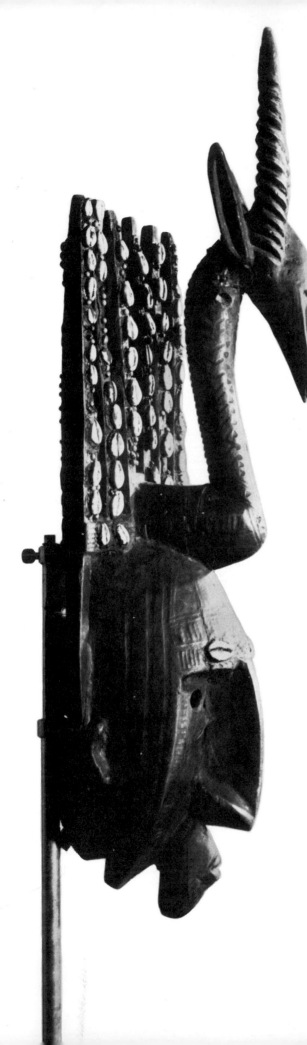

Young Bambara boys from Mali belong to a society called Ntomo, which is only open to those who have not yet been to initiation school. The Ntomo members have masks of their own to wear in dances after the millet harvest. During the dances, the boys beg gifts of food for their society celebration, and strike at each other with sticks to prove their bravery by not showing pain.

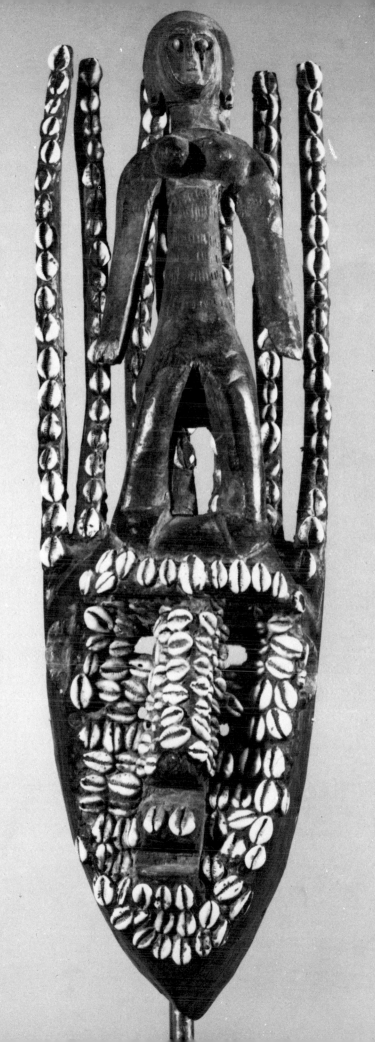

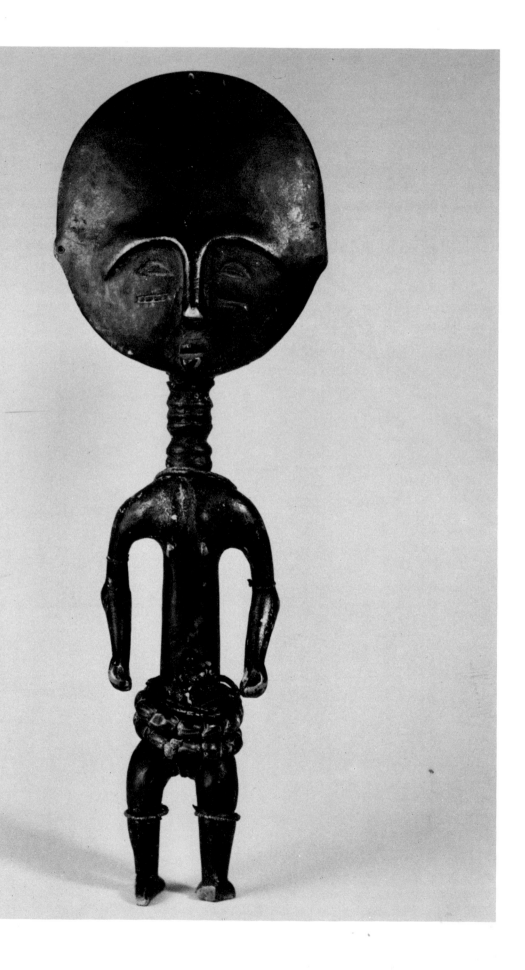

DOLL (Akua'ba)
Wood, beads
Ashanti, Ghana

We play and dance for you
That you may remain with us,
That you may bear ten children,
That no bad thing may come upon you.
Let the elephant give you her womb
That you may bear ten children.
Long live the people of your village,
Long live your relatives and elders
Who celebrate this festival for you.

Chant for Girls During Puberty Ceremony
Ashanti, Ghana

From their early years, traditional African girls prepare for the day when they will marry and become mothers themselves. Some are given fertility dolls to ensure that they will later have children. Among the Ashanti people of Ghana, these dolls are called akua'ba. They are carried in the young girls' skirtbands. The dolls' long necks and moon-shaped heads are considered signs of beauty that every future mother wishes for her child.

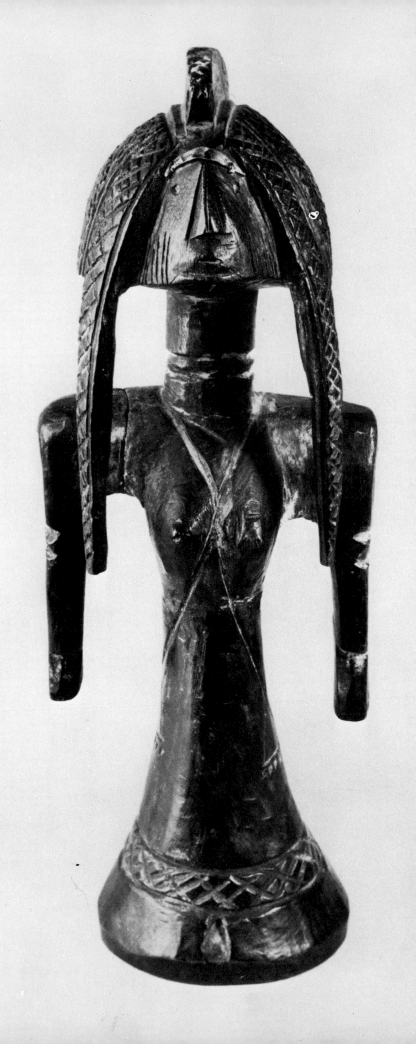

DOLL
Wood
Kenga, Chad

I have painted my eyes with black antimony
I girded myself with amulets.

I will satisfy my desire,
You my slender boy.
I walk behind the wall.
I have covered my bosom.
I shall knead colored clay
I shall paint the house of my friend,
O my slender boy.
I shall take my piece of silver
I will buy silk.
I will gird myself with amulets
I will satisfy my desire
the horn of antimony in my hand,
O my slender boy!

Bagirmi, Chad

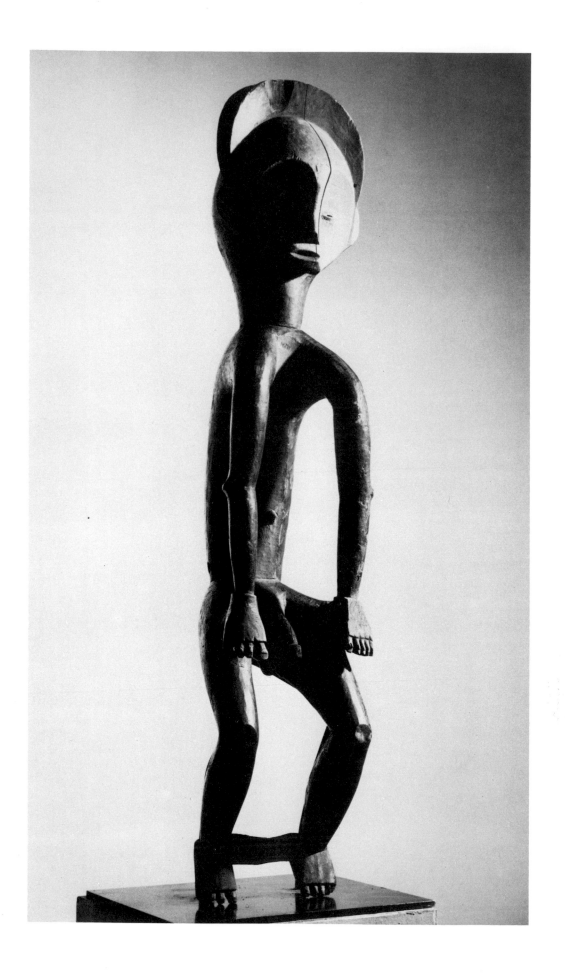

Among the Mbole people of Zaïre (the former Belgian Congo),
initiates of the Lilwa Society were bound to their oaths through
fear of punishment and death. At one time, those who betrayed
the oaths were said to have been murdered, had their bodies
smoked in a fire and hung up as an example to others. In later
years, wooden figures were used instead as a warning to the
initiates never to break their vows.

When most African boys and girls reach adolescence, they must leave their villages
and go to initiation schools in the bush. The girls are taught what their duties as wives
and mothers will be, and the boys are put through various ordeals to test their manli-
ness and courage.

Afterwards, the boys spend many months learning useful skills, as well as the laws
and traditions of their tribe. When they have completed their studies and been cir-
cumcized, they are admitted to the men's society as adults. They must swear oaths on
the society's most sacred possessions never to reveal its secrets.

The end of initiation is a time of joy and celebration. After a year away in the Nkanda bush school, the young Yaka men of Zaïre return in triumph to their homes. They dance through the village wearing wooden masks framed in masses of raffia fiber. Prizes are given to the best dancers and to the carver of the most clever mask. Then the new initiates dance on to nearby towns to receive admiration and praise from their friends.

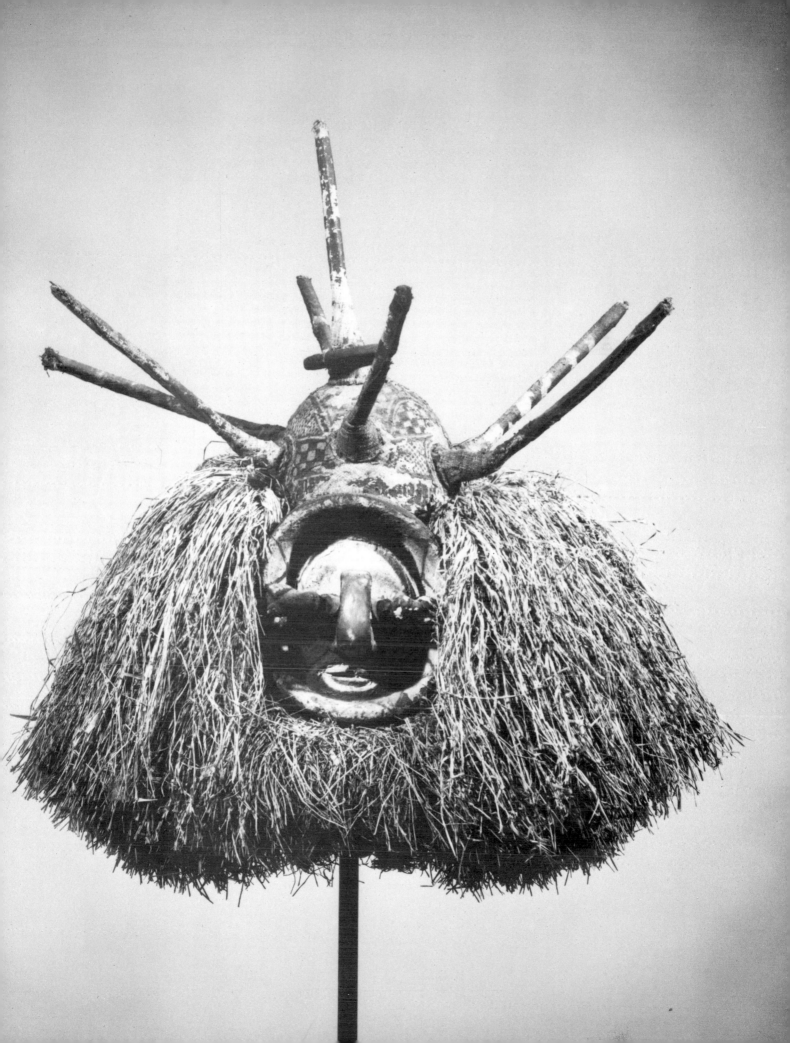

MASK
Wood and coloring
Songe, Zaïre

This mask is known as kifwebe, the Songe word for mask. It is
said to have been worn by the leader of the initiates when the
young men returned from the bush school.

Whatever I am taught,
let me remember it.
When the big fish comes out of the water
we can see the bottom of the pond.
When the big toad comes out of the water
we can see the bottom of the well.
When the kingfisher dives into the water
his brain becomes clear.
When the cheeks of the pregnant antelope were marked,
her child was also marked.
If there is one piece of meat left in the pot
it will surely be taken by the spoon.
Everything the landlord does
is known to the swallow.
Everything that is in your brain,
my father,
let it be known to me.

Yoruba, Nigeria

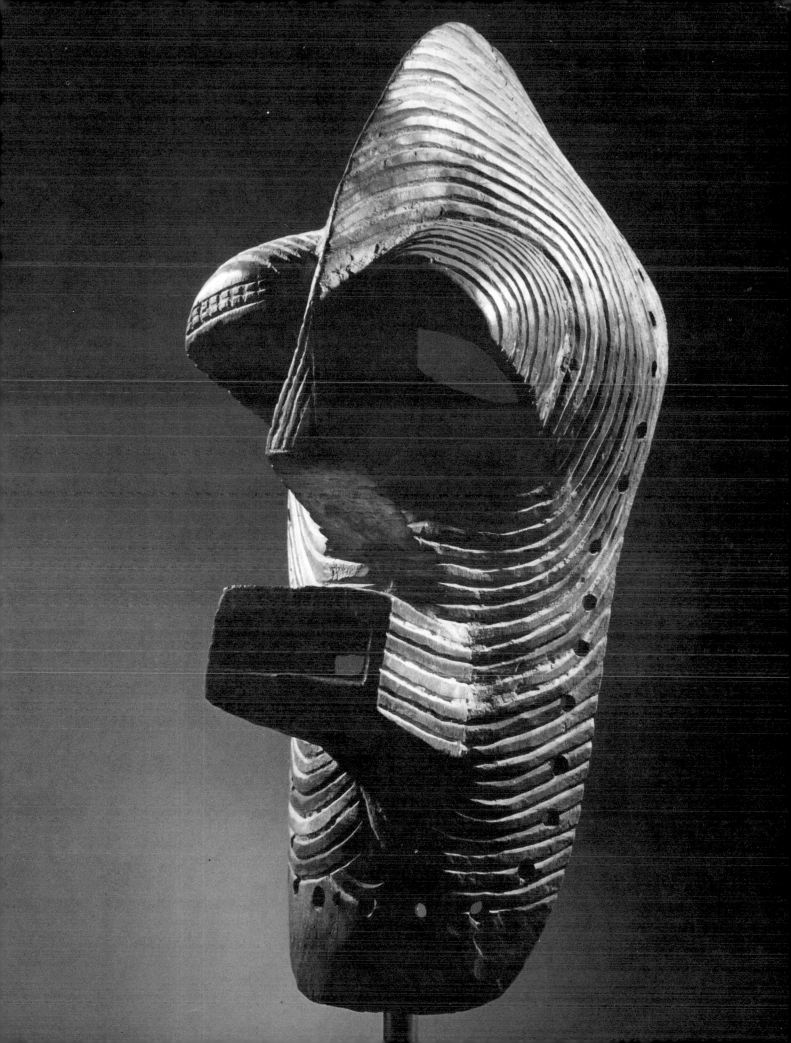

THE GROUND IS RINGING!

RHYTHM POUNDERS AND FIGURES
Wood
Senufo, Ivory Coast

Rhythm pounders were used by young initiates of the Lo
Society. They were lifted by the arms and pounded on the
ground in a slow, rhythmic dance to summon the ancestral
spirits. They may also have been used to purify the earth,
and to bring fertility to the tribe.

All of you, all of you
come, come, come, come,
let us dance
in the evening
when the sky has gone down river
down to the ground.

Kele, Zaïre

I was asleep,
I woke—someone calls me:
"You're asleep, Mugala!
Come out here and see
How the ground is ringing!"

Sumbwa, Tanzania

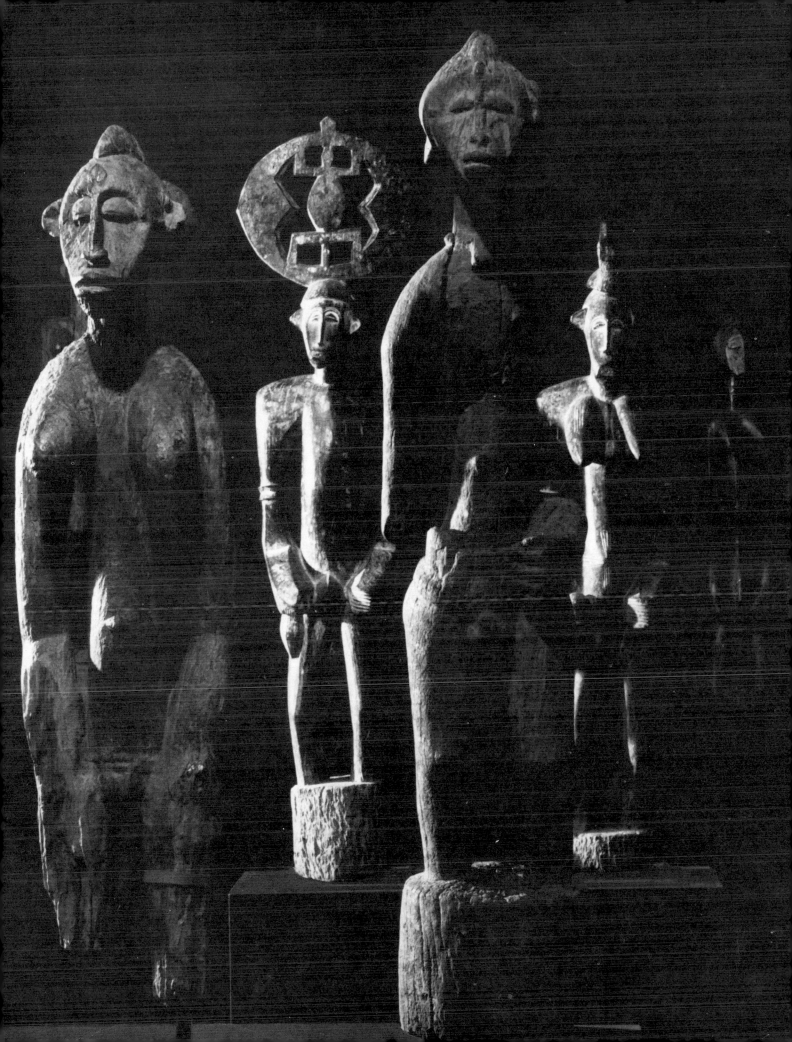

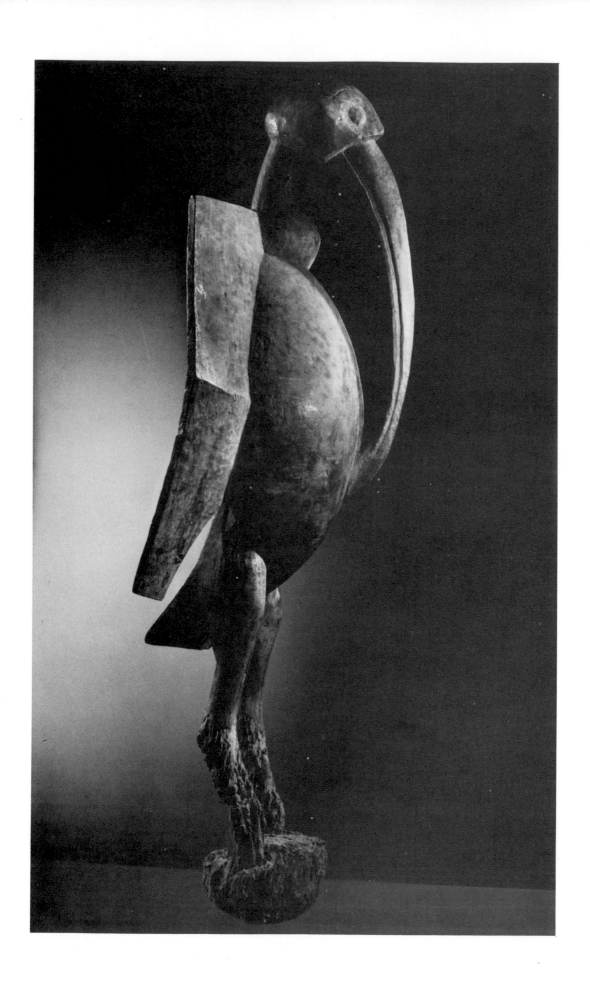

BIRD HEADDRESS (Porpianong)
Wood
Senufo, Ivory Coast

The mythical hornbill porpianong is a symbol of prosperity and
increase. In Senufo legend, it was one of the original creatures
on earth, and the first to have been used for food. The
porpianong headdress was worn by initiates of the Lo Society
during ceremonial dances. The base of the figure was hollowed
out to form a cap that fit on the dancer's head.

Among their many duties, the adult societies serve as custodians of the tribe's ances-
tral traditions. They preserve the myths, laws, and customs of the past, and dutifully
hand them down when each new generation is initiated. They are also responsible for
the observance of most religious rites and ceremonies, including those performed to
honor the spirits of nature.

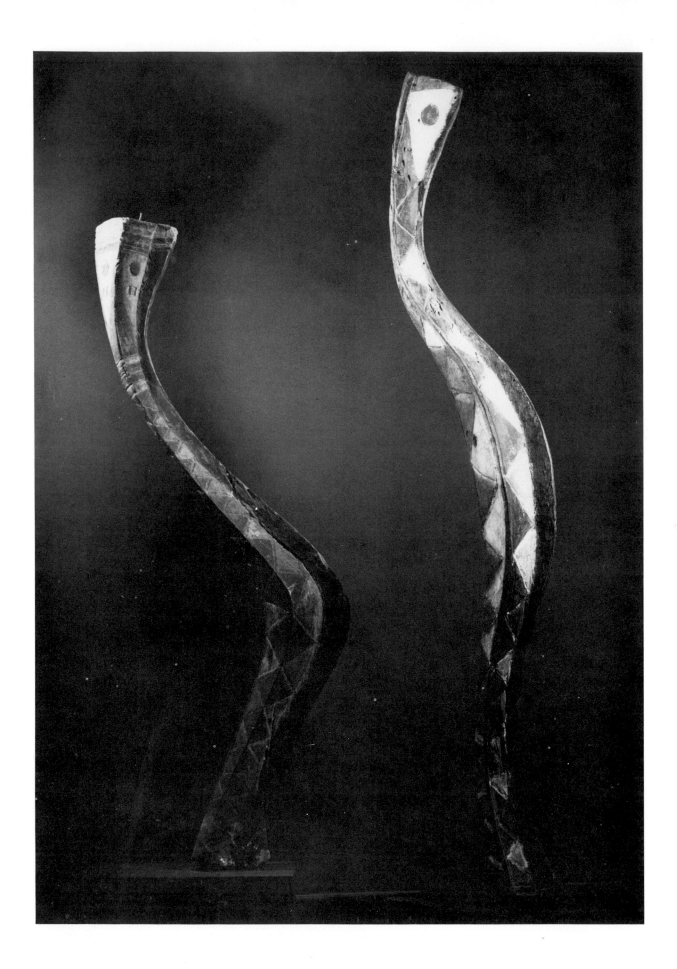

SNAKES (Pythons)
Wood and paint
Baga, Guinea

Swaggering prince
giant among snakes.
They say python has no house.
I heard it a long time ago
and I laughed and laughed and laughed.
For who owns the ground under the lemon grass?
Who owns the ground under the elephant grass?
Who owns the swamp—father of rivers?
Who owns the stagnant pool—father of waters? . . .

Yoruba, Nigeria

In the myths of the Baga people of Guinea, and other West African tribes, an ancient spirit in the form of a python came into the world when nothing existed but a marshy waste. The snake wound through the marshes and cut channels for the rivers, thus creating dry land where earthly creatures could survive. To the Baga, the python is a symbol of the continuation of life because of its rippling, unceasing motion. Images of the snake are used in initiation ceremonies and other secret society rites.

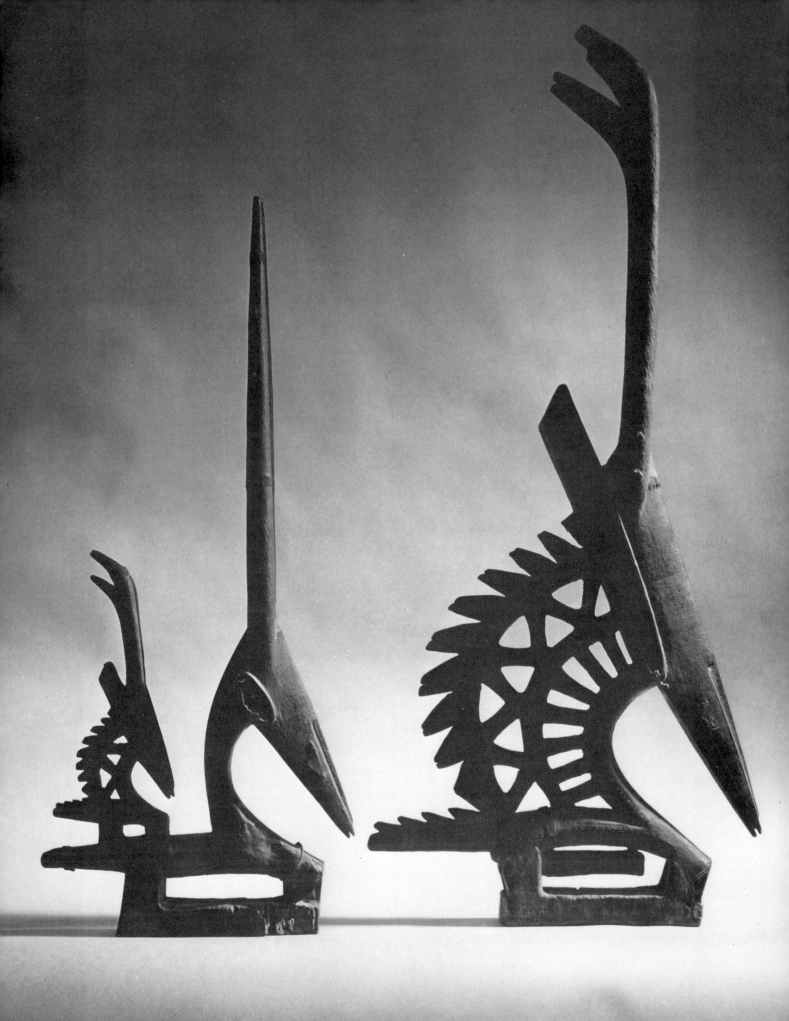

**Hey Chi Wara
Champion farmer come farm here
The field has become a competition
Come farm here before us all . . .**

Chi Wara Song
Bambara, Mali

When crops are hoed in the Bambara tribe of Mali, dancers wearing antelope head-dresses leap and bound over the fields accompanied by drummers and a chorus of girls. The masks honor Chi Wara, a mythical creature who taught the Bambara to grow grain. The larger mask represents a buck, the smaller, a female with her young. They are always worn in pairs to symbolize the idea of fertility. If they are separated during the dance, the Bambara believe that death and destruction will result.

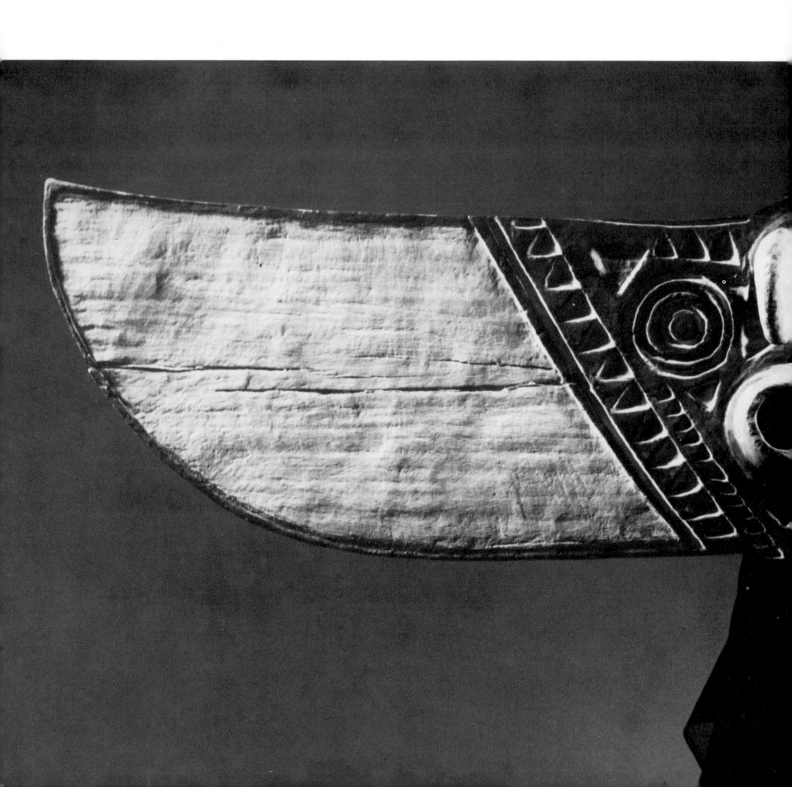

During the first spring rains in Upper Volta, vast swarms of butterflies suddenly appear. They signal that the time has come to plant the fields. The Bobo people of this country then perform butterfly dances with winged masks set sideways on their heads. They appeal to a deity named Do to bring abundant rain and fertility to the land. The horn in the center of the mask is said to impale any evil spirits that come near.

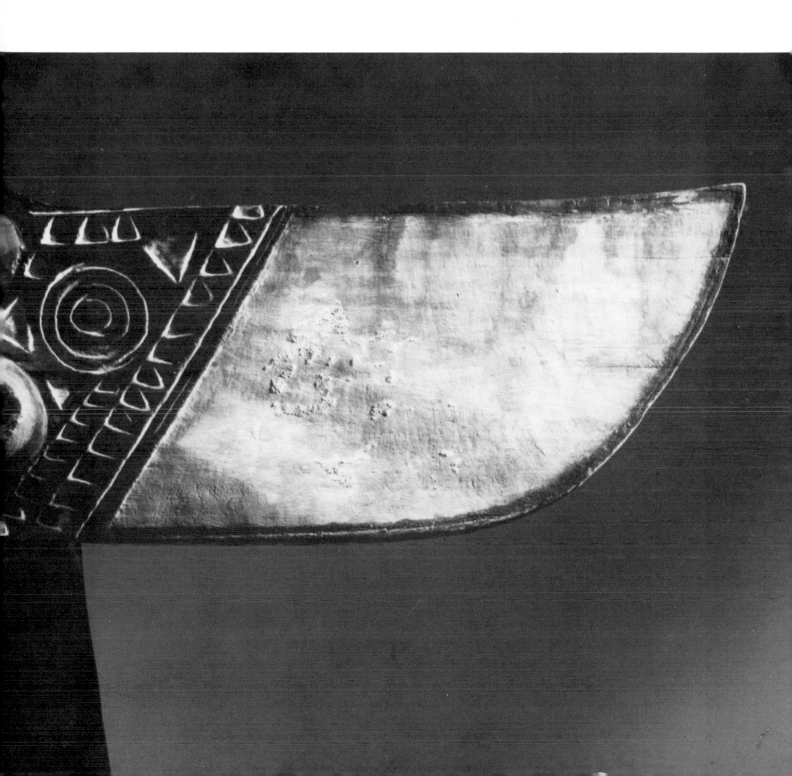

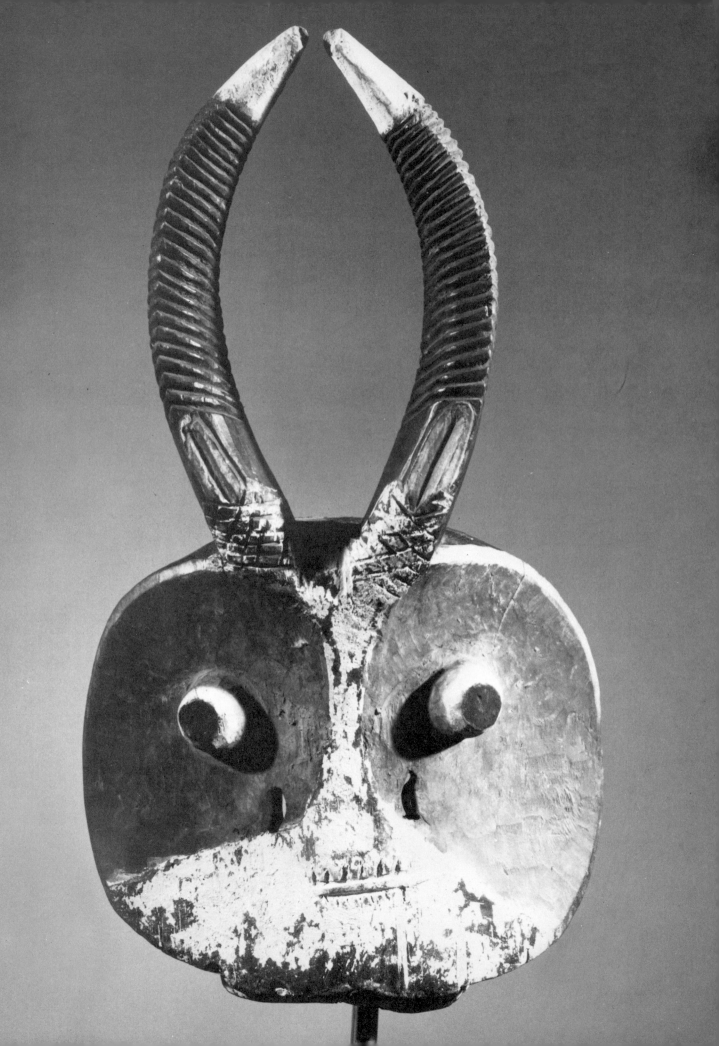

The buffalo is the death
that makes a child climb a thorn tree.
When the buffalo dies in the forest
the head of the household is hiding in the roof.
When the hunter meets the buffalo
he promises never to hunt again.
He will cry out: "I only borrowed the gun!
I only look after it for my friend!" . . .

Yoruba, Nigeria

Guli, the mighty Buffalo Spirit, is worshiped by the Baule people of the Ivory Coast. He is a protective spirit who is said to devour demons and witches. Late at night, a dancer wearing the Guli mask rushes through the village cracking a whip, accompanied by a blast of horns. Women and children run to hide in their houses so the spirit will not think they are demons and attack them by mistake.

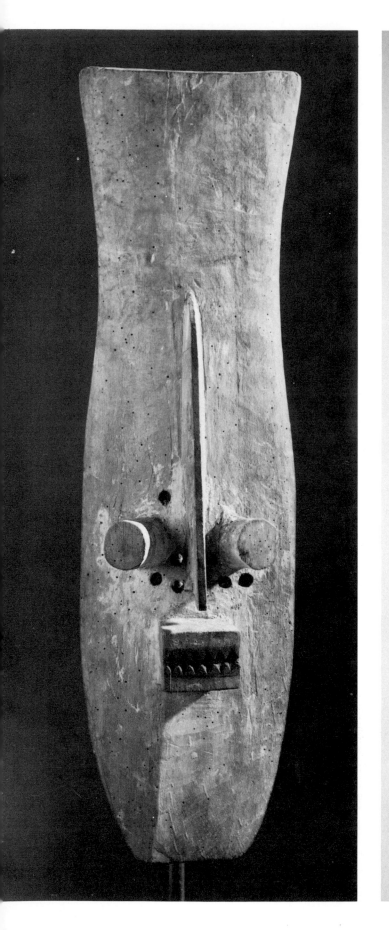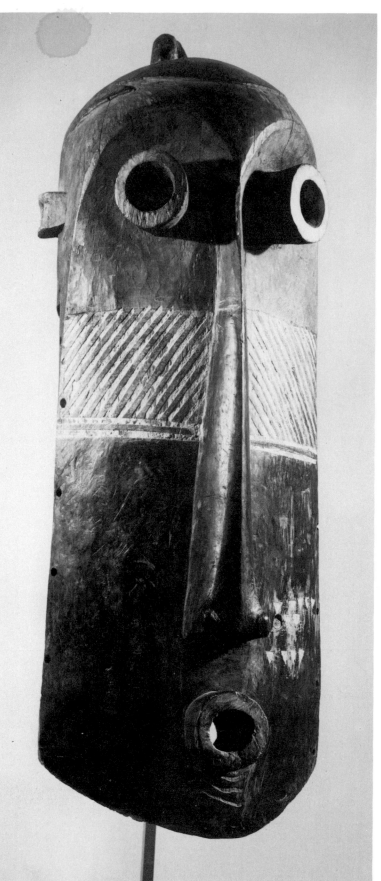

MASK
Wood and coloring
Teke, Zaïre

MASK
Wood, white and blue paint
Grebo, Liberia

MASK
Wood and coloring
Pende, Zaïre

Unlike the Guli mask, the butterfly mask and Chi Wara, many African masks invoke the presence of spirits whose names and meanings we may never know.

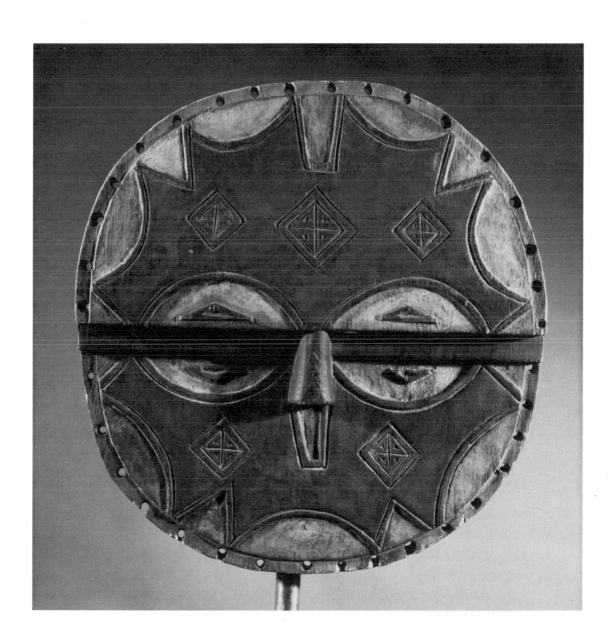

MASK (Poro Society)
Wood, coloring, iron pins, cowrie shells
Dan, Liberia

When disputes are settled in the Dan tribe of Liberia, a priest of the Poro Society wears a mask that represents the spirit of a woman. As soon as the priest puts on the mask, he is possessed by the woman's spirit and temporarily transformed into her personality. He then moves about listening to the case, and asking questions in a high, feminine voice. His decision in the matter is thought to be the impartial judgment of the spirit, and therefore it cannot be challenged.

It has been said that the duties of the secret societies never end, for the business of life passes through their hands. Not only are they responsible for religious traditions and ceremonies, but also for maintaining order in the tribe.

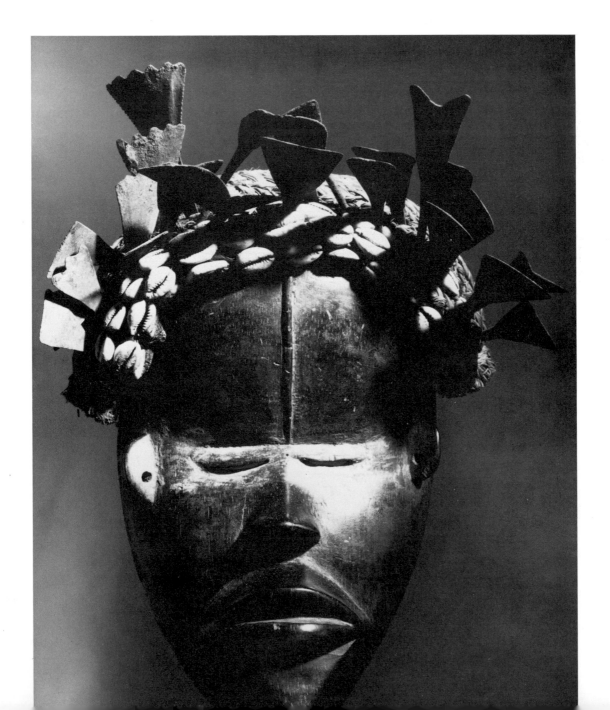

MASK (Poro Society)
Wood, cloth, paint, and other materials
Ngere, Liberia

Let not the civet-cat trespass on the cane rat's track.
Let the cane rat avoid trespassing on the civet-cat's path.
Let each animal follow the smooth stretch of its own road.

Proverb
Yoruba, Nigeria

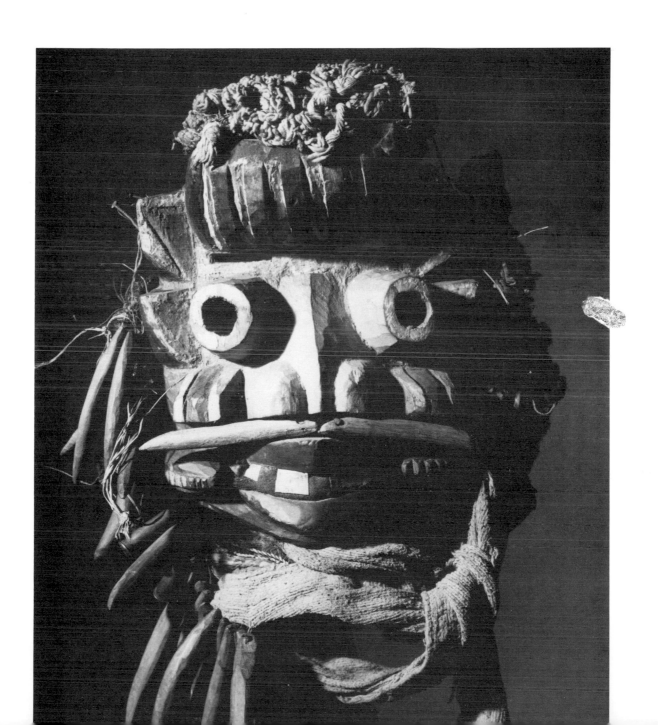

KING OF ALL KINGS

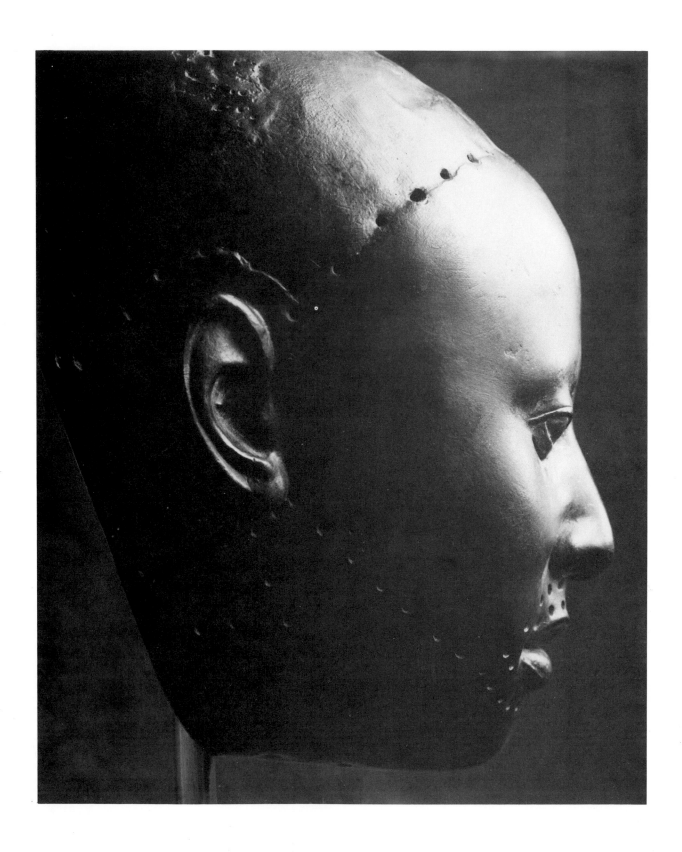

MASK
Copper (cast)
Court of Ife, Yoruba, Nigeria
VIII-XI Centuries

Child of death,
Father of all mothers,
King of all kings.
You carry the blackness of the forest
like a royal gown.
You carry the blood of your enemies
like a shining crown.
Be merciful with us,
as the silk cotton tree is merciful with the forest,
as the eagle is merciful with the birds.
The town rests in the palm of your hand,
weightless and fragile.
Do not destroy it:
our fate rests in your hand,
wield it carefully
like your beaded sceptre.
The enemies who want to destroy you,
will destroy themselves.
When they want to roast maize,
they will set fire to their roof.
When they want to sell water—
there will be drought.
The sieve will always be master of the chaff.
The water lily will always float on the lake.
Child of death,
the hairs on your chest are as numerous
as the words of a talkative woman.
You grab the heads of your enemies,
and push their faces into boiling water.
You lock the door in front of their noses
and keep the key in your pocket.
Child of death,
Father of all mothers,
King of all kings.

Yoruba, Nigeria

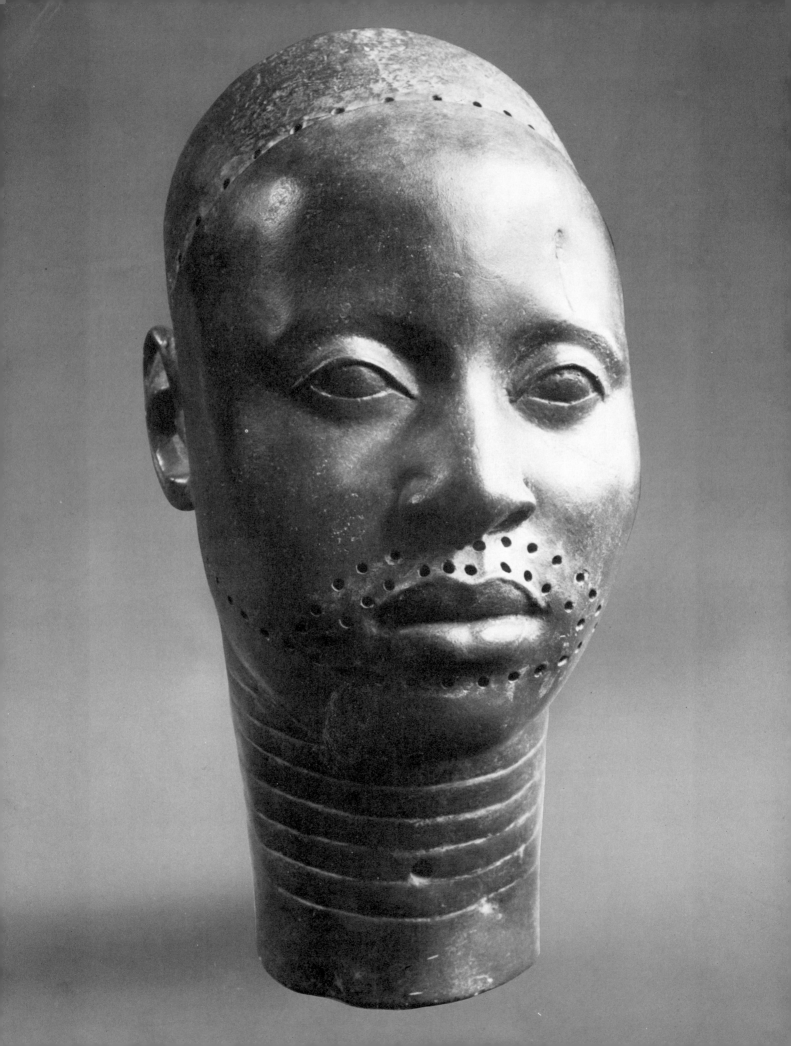

HEAD
Brass (cast)
Court of Ife, Yoruba, Nigeria
VIII–XI Centuries

With delicacy and precision, the bronzesmiths of Ife cast
beautiful brass masks and heads. The sculptures were probably
made between the eighth and eleventh centuries A. D., during
the high period of Ife culture. They are thought to represent the
first Onis of Ife, although it is not known if they were intended
to be portraits. The small holes in the faces may once have held
black glass beads or tufts of human hair.

More than a thousand years ago in Nigeria, a great kingdom was built around the reli-
gious center of Ife by the people of the Yoruba tribe. It was ruled by a priest-king, the
Oni of Ife, who held sway over the chiefs, or obas, of the other towns. The Oni em-
ployed a guild of artists to produce works solely for the royal court. These artists knew
how to cast bronze, a technique unknown at that time in many parts of the world.

BELT MASK
Ivory
Court of Benin, Bini, Nigeria
about 1520

The early Obas of Benin were said to have worn ivory masks attached to their belts as emblems of their rule. This mask was carved about 1520. On the crown are little heads representing Portuguese men. Portuguese explorers first arrived in 1472, and by the time this mask was carved, they were well known in Benin. Ivory belt masks are still worn by the present Oba of Benin, a custom that has endured for at least four hundred and fifty years.

Not many miles from Ife is the city of Benin, the capital of a once-powerful empire built by the Bini tribe. According to an ancient Bini legend, Benin was founded shortly after the creation of Ife, when the first Oni was still alive. The early people of Benin could not choose a ruler, so they asked the Oni to send one of his sons to be their king. The Oni sent his son Oranyan, who became the first Oba of Benin.

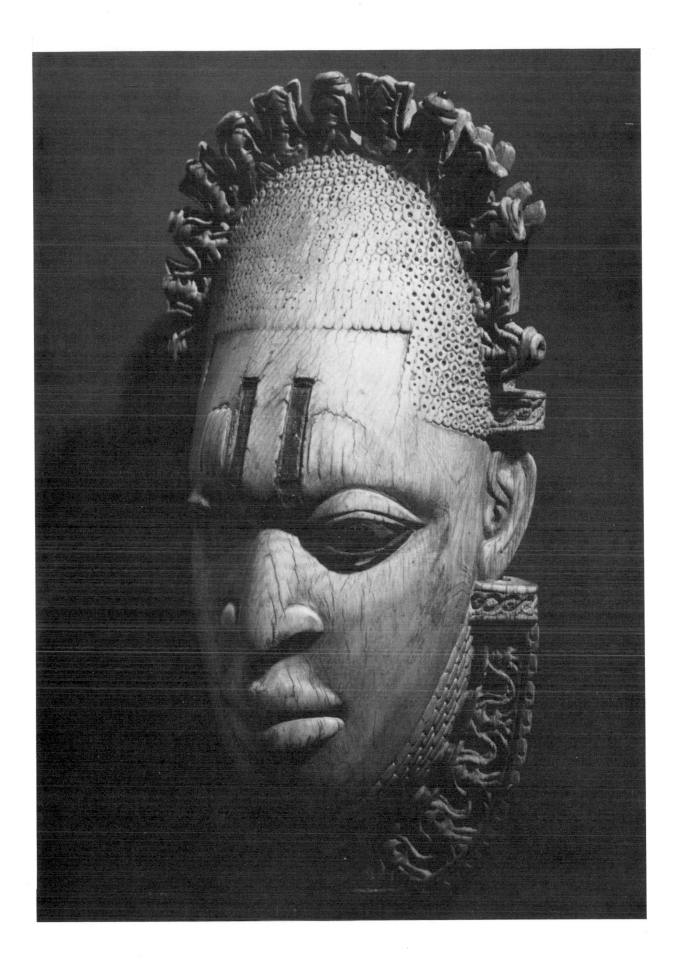

FIGURE OF HORNBLOWER
Bronze
Court of Benin, Bini, Nigeria
about 1550-1680

FIGURE OF HORNBLOWER (Back view)
Bronze
Court of Benin, Bini, Nigeria
about 1550-1680

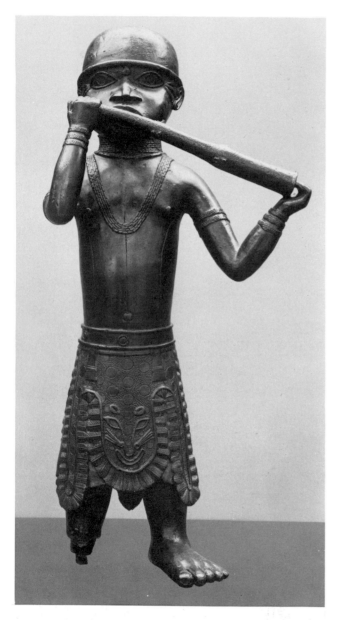

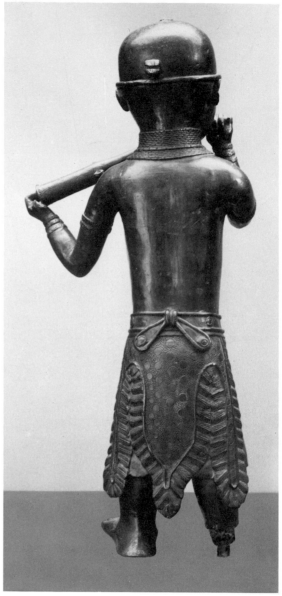

The artists of Benin learned to cast bronze from the royal smiths of Ife, and for a long time they were influenced by Ife's art style. But over the years, as Ife declined and Benin grew rich and powerful, Benin artists developed a style of their own that served to glorify the royal court. In the sixteenth and seventeenth centuries, they made bronze figures of court attendants, probably to show the Obas' wealth and prestige. They also made hundreds of bronze plaques to decorate the wooden pillars of the royal palace. Each plaque depicted a scene of Benin court life.

PLAQUE WITH PALACE GUARD (Detail)
Bronze
Court of Benin, Bini, Nigeria
about 1550–1680

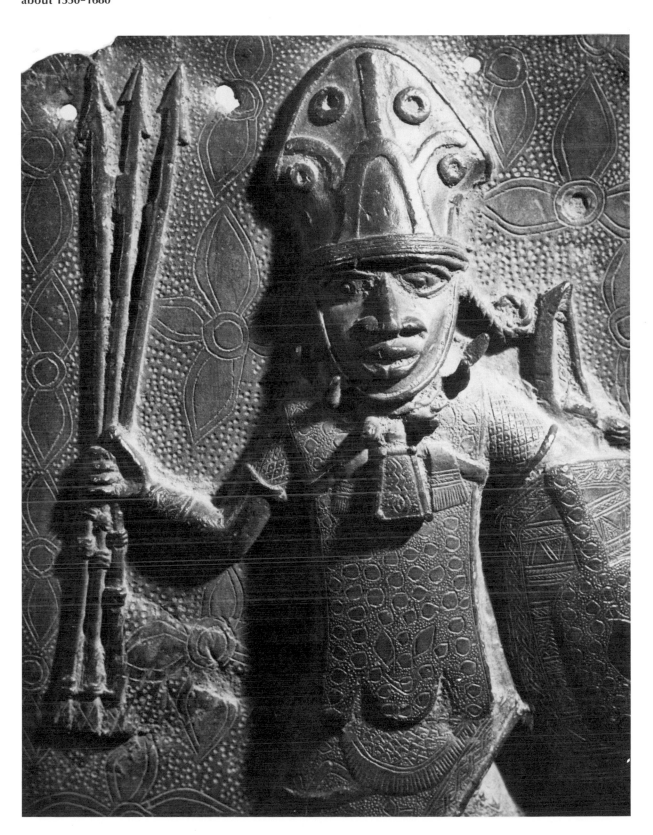

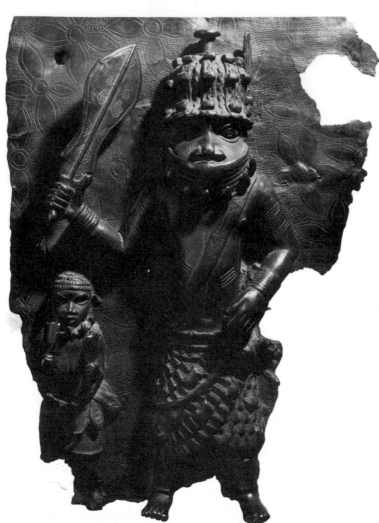

PLAQUE WITH KING
Bronze
Court of Benin, Bini, Nigeria
about 1550–1680

This plaque shows the Oba, with a
small attendant beside him. He holds
a sword, and wears a crown and high
collar of coral beads, symbols of his
royal station.

PLAQUE WITH KING AND ATTENDANTS
Bronze
Court of Benin, Bini, Nigeria
about 1550–1680

Here the Oba sits regally on a horse. Two
attendants hold large palm leaves to shade
him from the sun, while two others support
his arms. Some of the figures are made
smaller than the others to point out the
differences in their rank.

He who knows not the Oba
let me show him.
He has mounted the throne,
he has piled a throne upon a throne.
Plentiful as grains of sand on the earth
are those in front of him.
Plentiful as grains of sand on the earth
are those behind him.
There are two thousand people
to fan him.
He who owns you
has piled a throne upon a throne.
He has lived to do it this year;
even so he will live to do it again.

Bini, Nigeria

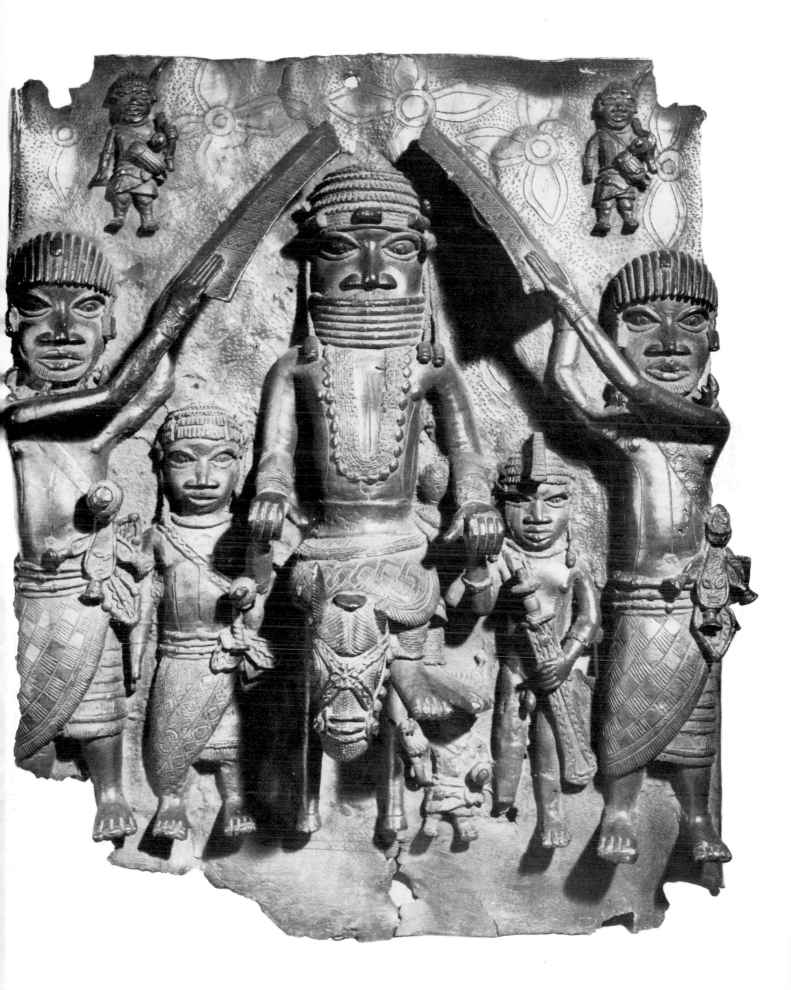

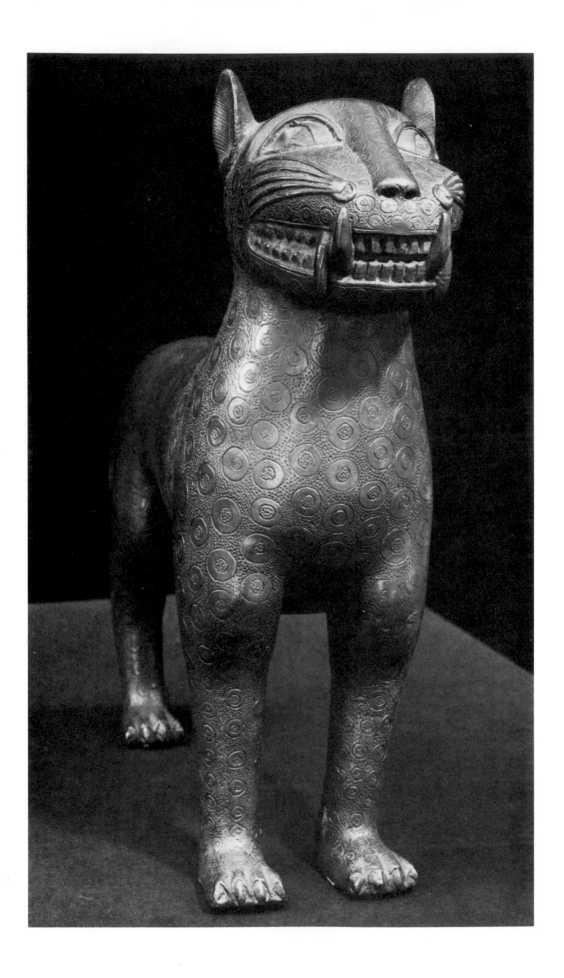

LEOPARD
Bronze
Court of Benin, Bini, Nigeria
about 1750

Gentle hunter
his tail plays on the ground
while he crushes the skull.

Beautiful death
who puts on a spotted robe
when he goes to his victim.

Playful killer
whose loving embrace
splits the antelope's heart.

Poem to the Leopard
Yoruba, Nigeria

Leopards were the royal animals of Benin. They were tamed and kept in the palace as pets. Their images were symbols of kingship, and only those persons favored by the Oba were allowed to wear leopard-skin clothes. The royal hornblower already shown must have enjoyed this privilege, as the face of a leopard is embossed on the front of his spotted skirt.

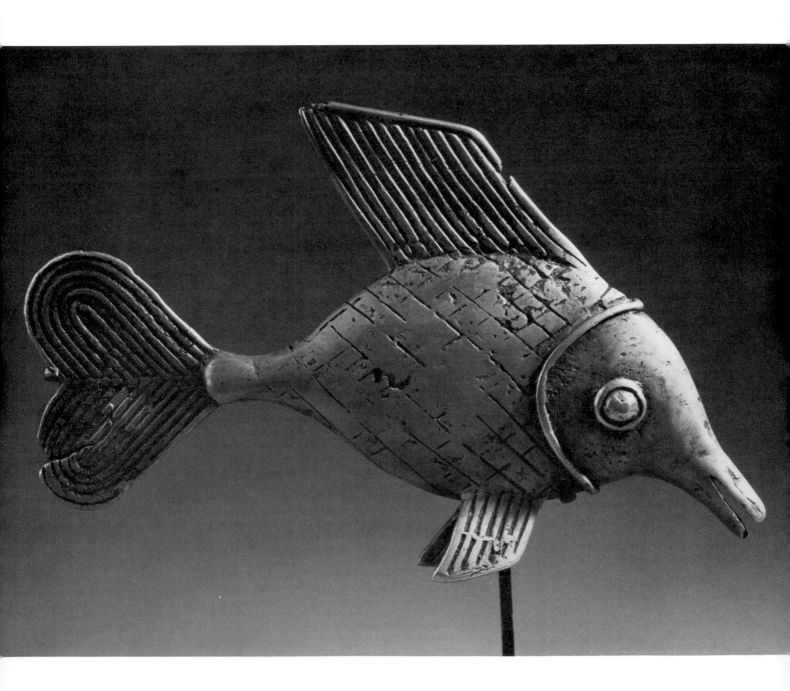

The edges of the year have met.
The chief has given you yams, he has
 given you sheep.
He has given you eggs, and now he has
 brought this drink.
Let the tribe prosper, may the women
 bear children;
Do not let our children die;
Those who have gone to trade, may they
 get money;
May there be peace in the present chief's
 reign.

Ashanti, Ghana

Emblems of kingship exist in many forms. In the Ashanti kingdom of Ghana, which was once called the Land of Gold, brass weights of various shapes were used to weigh gold dust on a scale. At one time, the weights were symbols of royalty owned only by the king and queen-mother, but later they were used by traders and merchants as well.

ORIKI OGUN

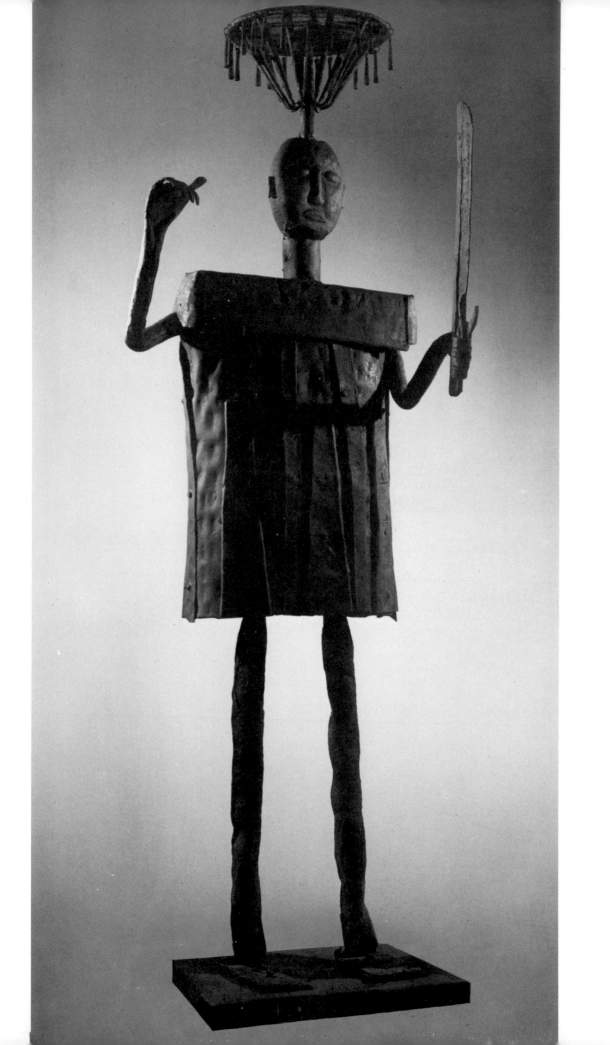

Brass
Fon, Dahomey

Gu, the God of War and Iron, is worshiped by the Fon tribe of
Dahomey. He is identified with the Yoruba god Ogun. This
figure was riveted together from sheets of pounded brass, and
was probably made for the royal court of the Fon.

Ogun kills on the right and destroys on the right.
Ogun kills on the left and destroys on the left.
Ogun kills suddenly in the house and suddenly in the field.
Ogun kills the child with the iron with which it plays.
Ogun kills in silence.
Ogun kills the thief and the owner of the stolen goods.
Ogun kills the owner of the slave and the slave runs away.
Ogun kills the owner of the house and paints the hearth with his blood.
Ogun is the death that pursues a child until it runs into the bush.
Ogun is the needle that pricks at both ends.
Ogun has water but he washes in blood.

Ogun sacrifices an elephant to his head.
Master of iron, head of warriors.
Ogun, great chief of robbers.
Ogun wears a bloody cap.
Ogun has four hundred wives and one thousand four hundred children.

Ogun, the fire that sweeps the forest.
Ogun's laughter is no joke.
Ogun eats two hundred earthworms and does not vomit.

Ogun is not like something you can throw into your cap.
Do you think you can put on your cap and walk away with him?

The light shining in Ogun's face is not easy to behold.
Ogun, let me not see the red of your eye.

Oriki Ogun
Yoruba, Nigeria

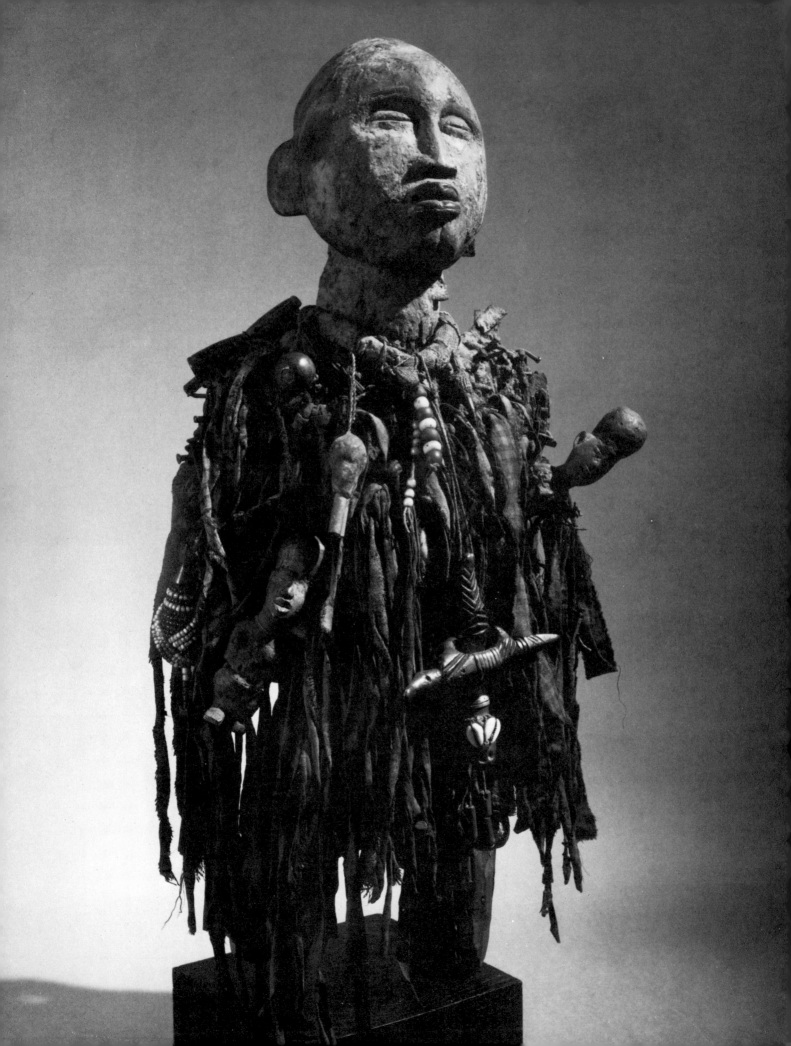

FETISH FIGURE Konde
Wood, cloth, metal, beads, shells, and other materials
Kongo, Zaïre

The fetish known as konde is used by the Kongo people of
Zaïre. It is covered with a mysterious array of cloth, dolls, beads,
shells, and metal amulets. These objects are magical charms that
increase the powers of the spirit. When the Kongo want to
place a curse or cause the death of an enemy, they drive nails
into the konde to summon the spirit to action. Each nail
symbolizes a ritual murder or punishment to be carried out.

May the leopard coming from the forest
Have his teeth on edge for these animals.
May the weasel coming from the forest
Be unable to take these fowls.
May the witch who twists his belongings,
Fail to fascinate our goats . . .

Kongo, Zaïre

At times, the order and harmony of the world are disrupted by the violence of men,
or the malicious actions of witches and demons. To bring peace and well-being back
to the tribe, the spirits dwelling within fetish figures are called upon to drive out the
malevolent forces.

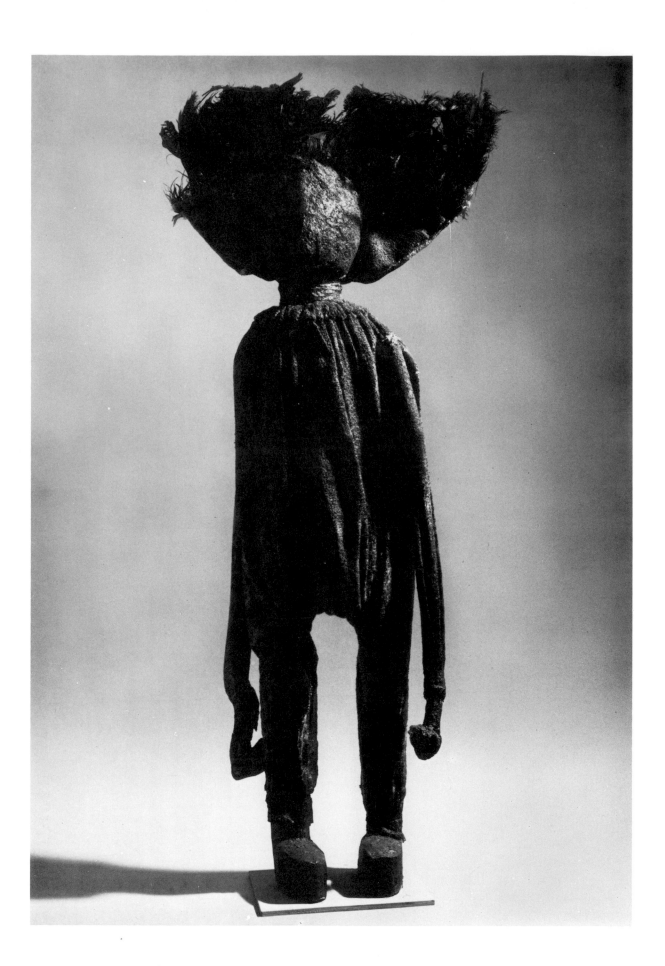

FETISH FIGURE
Wood, cloth, feathers, and other materials
Senufo, Ivory Coast

O Witch, don't kill me, Witch
please spare me, Witch
this Holy Drummer swears to you that
when he rises up some morning
he will sound his drums for you some morning
very early
very early
very early.
O Witch that kills our children very early
O Witch that kills our children very early
this Holy Drummer swears to you that
when he rises up some morning
he will sound his drums for you some morning
very early
very early
very early.
Hear me talking to you.
Try to understand.

Drum Poem
Ashanti, Ghana

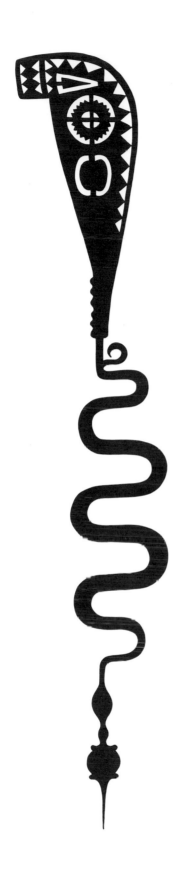

DEATH SONG

MASK
Wood, black and white paint
Luba, Zaïre

This mask is said to have been worn during the funerals of Luba chiefs.

There is no needle without piercing point.
There is no razor without trenchant blade.
Death comes to us in many forms.

With our feet we walk the goat's earth.
With our hands we touch the God's sky.
Some future day in the heat of noon,
I shall be carried shoulder high
through the village of the dead.
When I die, don't bury me under forest trees,
I fear their thorns.
When I die, don't bury me under forest trees,
I fear their dripping water.
Bury me under the great shade trees in the market.
I want to hear the drums beating,
I want to feel the dancers' feet.

Kuba, Zaïre

When death occurs in the community, the mourners chant dirges and extol the virtues of the deceased. Dancers wearing costumes and masks often appear to invoke the ancestral spirits. Through the vehicle of the masks, the spirits participate in the funeral, and they are asked to guide the dead person's soul safely to the other world.

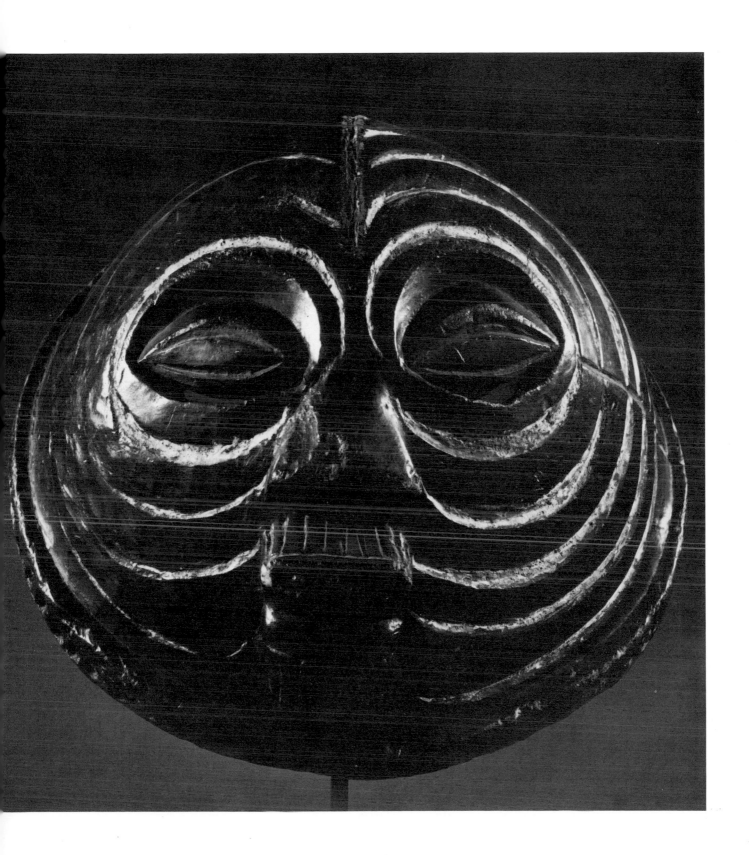

GHOST MASK
Wood, red, white and black paint
Ogowe River area, Gabon

Slowly the muddy pool becomes a river
slowly my mother's disease becomes death.
When wood breaks, it can be repaired.
But ivory breaks for ever . . .

Yoruba, Nigeria

The white face mask from the Ogowe River area of Gabon represents the ghost of a woman who has returned from the land of the dead. It is said to be a portrait of a beautiful girl whose features were "stolen" by the carver and secretly reproduced on the mask. During funeral ceremonies, the mask was worn with a raffia costume by a dancer on tall, wooden stilts. In many parts of Africa, white is a symbol of death, the color of spirits and ghosts.

The Ashanti people of Ghana place terra-cotta heads on the graves of the dead to protect them from malevolent forces. The heads represent guardian spirits, and they may also be portraits of the deceased. In former times, they were placed on display during the funerals of Ashanti kings.

In the olden days, when you were
On your way to Akora Kusi's house,
You would stumble over skulls;
Vultures got up to greet you;
Blue bottle flies buzzed around you
As if to say, Alas!

Dirge for a Royal Ancestor
Ashanti, Ghana

Even in death, men's souls are not safe from the forces of evil. Witches and demons try to lead them astray in the dark regions of the underworld.

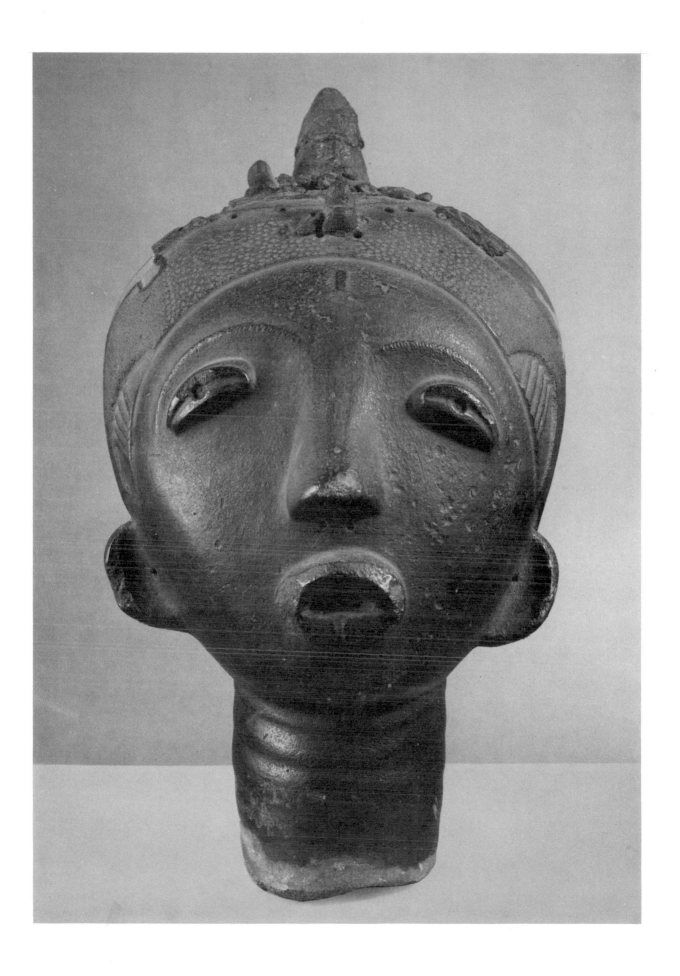

RELIQUARY FIGURE
wood, copper, brass
Kota, Gabon

RELIQUARY HEAD Bieri
wood, metal
Fang, Gabon

In the Fang and Kota tribes of Gabon, guardian figures watch over packages containing the skulls and bones of the dead. The figures are thought to embody the spirits of the first tribal ancestors, and to be symbols of the tribe as a whole. The Fang head is known as bieri. It was kept on a family shrine above a wooden box where the dead person's bones were stored.

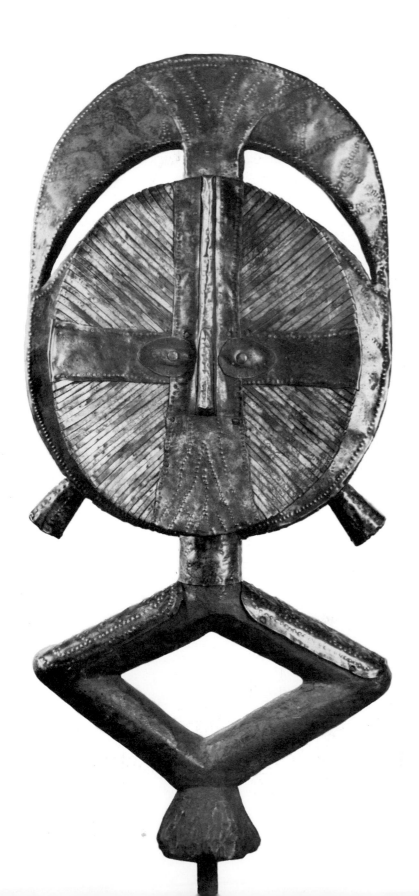

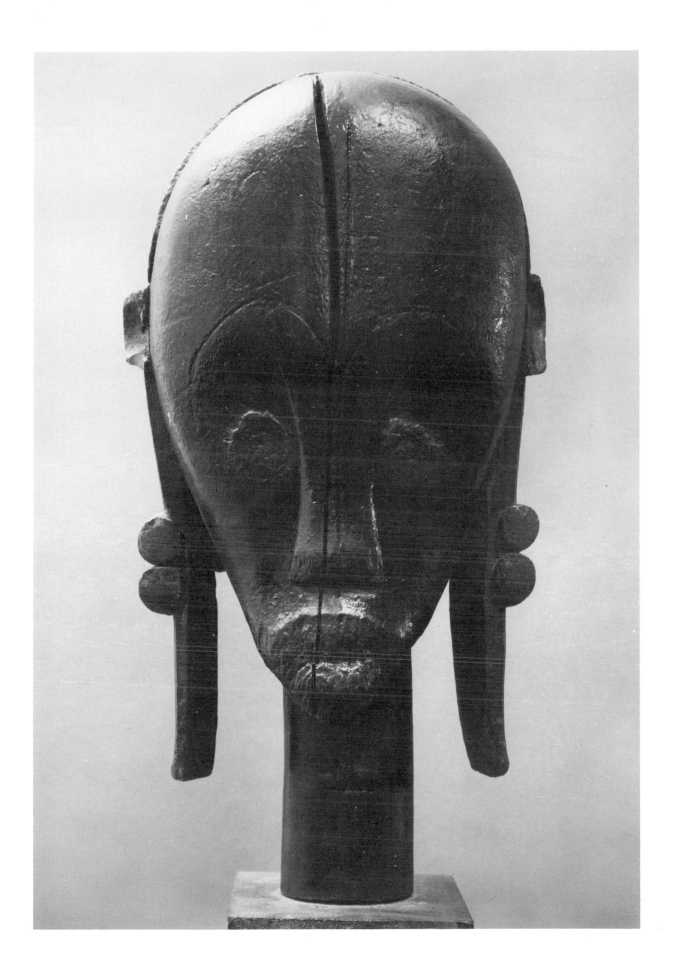

Fire that men see only at night, dark night,
Fire that burns without warming, that shines
 without burning,
Fire that flies without body and without support
 that knows neither house nor hearth,
Transparent fire of palm trees, a man without fear
 calls you . . .

Fang, Gabon

The dead vanish into the depths of the earth, but their spirits never die. They join the hosts of ancestors, and use their power as spirits to work for the benefit of the tribe. Memorial figures are carved in their honor, to provide them with a temporal place to reside. The figures are treated with great respect, as through them the ancestors remain symbolically and spiritually alive.

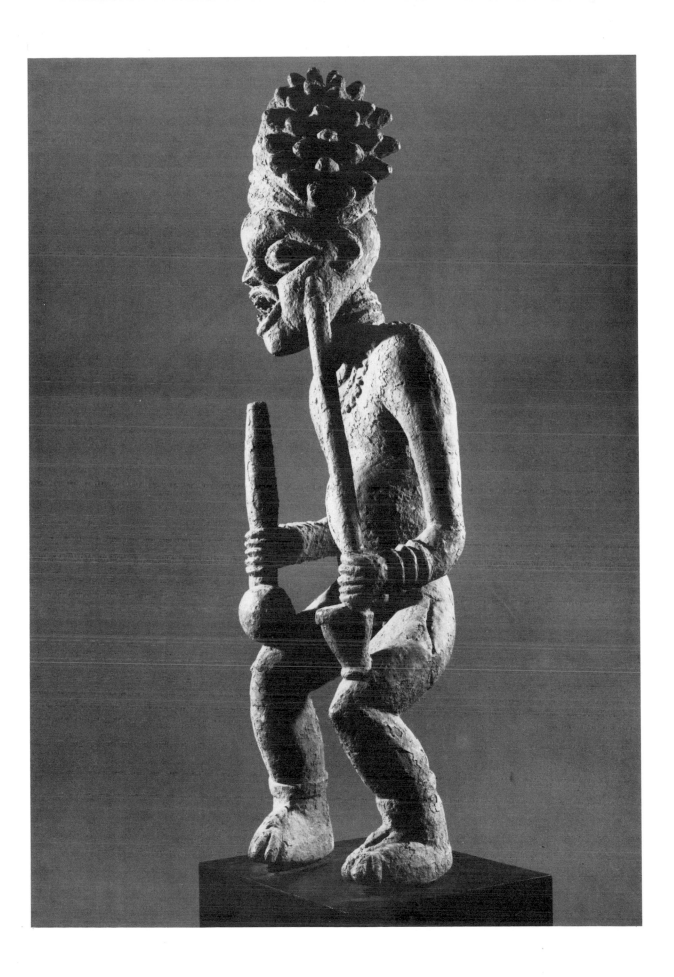

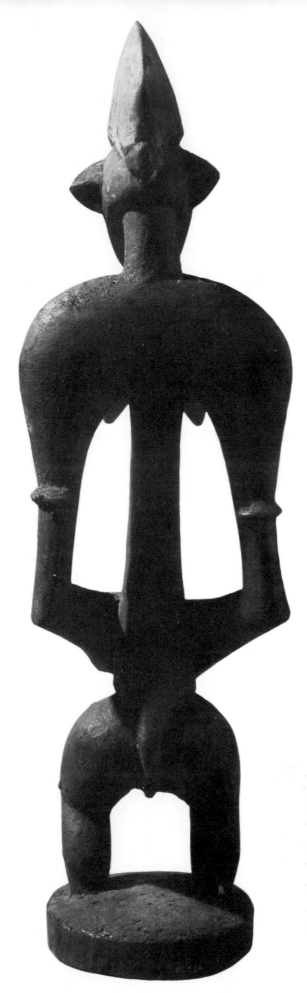

MOTHER AND CHILD ANCESTOR FIGURE
Wood
Bambara, Mali

STANDING FIGURE (Rear view)
Wood
Senufo, Ivory Coast

Through the endless cycle of death and re-
birth, the rhythm of creation flows. The sa-
cred order of the world is never destroyed,
nothing is wasted or lost. After fallow times,
the earth becomes fertile; after death, new
young issue forth. All things grow and in-
crease, nourished by the spiritual essence of
life.

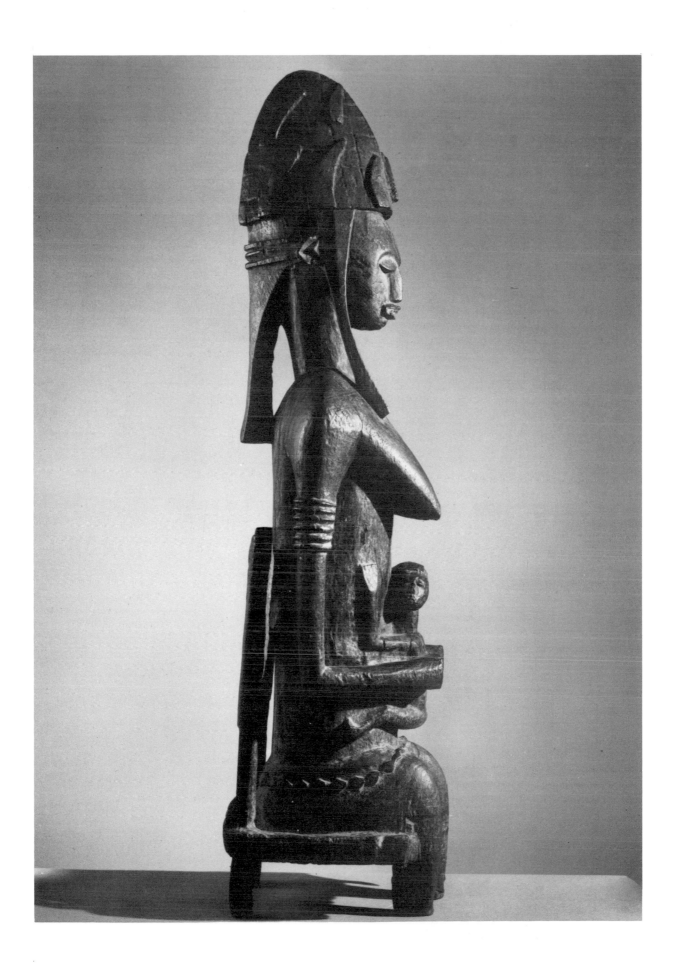

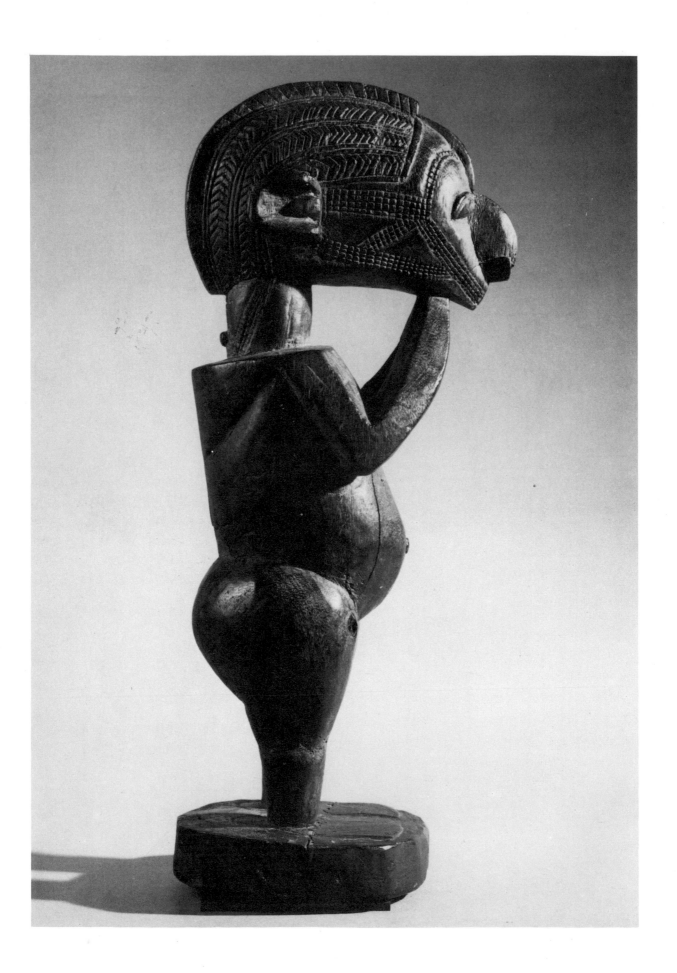

Iwori wotura
Anybody who sees beauty and does not look at it
will soon be poor.
Red feathers are the pride of the parrot.
Young leaves are the pride of the palm tree.
Iwori wotura.
White flowers are the pride of the leaves.
A swept verandah is the pride of the landlord.
Iwori wotura.
A straight tree is the pride of the forest.
A fast deer is the pride of the bush.
Iwori wotura.
The rainbow is the pride of heaven.
A beautiful woman is the pride of her husband.
Iwori wotura.
Children are the pride of their mother.
The moon and stars are the pride of the sun.
Ifa says,
Beauty and all sorts of good fortunes arrive.

Yoruba, Nigeria

BIBLIOGRAPHY

AFRICA: THE ART OF THE NEGRO PEOPLES by Elsy Leuzinger, Crown Publishers, New York, 1960

AFRICAN ART by Dennis Duerden, Paul Hamlyn, London, 1968

AFRICAN ART by Frank Willett, Praeger and Company, New York, 1971

AFRICAN ARTS, Volume IV, Number 1: "The Dance of the Tyi Wara" by Pascal James Imperato, Los Angeles, 1970

AFRICAN FOLKTALES by Paul Radin, Bollingen Series, Princeton, 1970

AFRICAN KINGDOMS by Basil Davidson, Time, New York, 1966

AFRICAN MASKS by Franco Monti, Paul Hamlyn, London, 1969

AFRICAN MYTHOLOGY by Geoffrey Parrinder, Paul Hamlyn, London, 1967

AFRICAN POETRY, ed. by Ulli Beier, Cambridge University Press, Cambridge, 1970

AFRICAN SCULPTURE by William Fagg, International Exhibitions Foundation, Washington, 1970

AFRICAN SCULPTURE: A DESCRIPTIVE CATALOGUE by Elsy Leuzinger, Museum Rietberg, Zürich, 1963

AFRICAN SCULPTURE SPEAKS by Ladislas Segy, Hill and Wang, New York, 1969

AFRICAN TRIBAL IMAGES: THE KATHERINE WHITE RESWICK COLLECTION by William Fagg, Museum of Art, Cleveland, 1968

AFRICAN TRIBAL SCULPTURE (catalogue), University Museum, Philadelphia, 1965

AFRICAN WORLDS, ed. by Daryll Forde, Oxford University Press, London, 1954

THE AKAN OF GHANA by Eva Meyerowitz, Faber and Faber, London, 1958

ANTS WILL NOT EAT YOUR FINGERS: Traditional African Poetry, ed. by Leonard Doob, Walker and Company, New York, 1966

ART OF AFRICA: TRIBAL MASKS from the Náprstek Museum, Prague, Paul Hamlyn, London, 1968

THE ART OF WESTERN AFRICA by William Fagg, New American Library, New York, 1962

BAMBARA SCULPTURE FROM THE WESTERN SUDAN by Robert Goldwater, Museum of Primitive Art, New York, 1960

CLASSIC BLACK AFRICAN POEMS, ed. by Willard R. Trask, The Eakins Press, New York, 1971

IFE IN THE HISTORY OF WEST AFRICAN SCULPTURE, by Frank Willett, New York, 1967

ORAL LITERATURE IN AFRICA by Ruth Finnegan, Oxford University Press, London, 1970

PANOPLY OF GHANA by A. Kyermatea, Frederick Praeger, New York, 1964

SCULPTURE FROM THREE AFRICAN TRIBES, Museum of Primitive Art, New York, 1959

THE SCULPTURE OF AFRICA by Eliot Elisofon and William Fagg, Frederick Praeger, New York, 1958

THE SCULPTURE OF BLACK AFRICA: THE TISHMAN COLLECTION, Los Angeles County Museum of Art, Los Angeles, 1969

SENUFO SCULPTURE FROM WEST AFRICA, Museum of Primitive Art, New York, 1963

TECHNICIANS OF THE SACRED, ed. by Jerome Rothenberg, Doubleday & Company, Inc., Garden City, New York, 1968

TRIBES AND FORMS IN AFRICAN ART by William Fagg, Tudor Publishing Company, New York, 1965

THE UNWRITTEN SONG, ed. by Willard R. Trask, The Macmillan Company, New York, 1967-68

WEST AFRICAN SCULPTURE by Rene A. Bravmann, Henry Art Gallery/University of Washington Press, Seattle, 1970

WEST AFRICAN SECRET SOCIETIES by F. W. Butt-Thompson, H. F. and G. Witherby, London, 1929

WITCHCRAFT IN GHANA by the Reverend H. Debrunner, Presbyterian Book Depot, Accra, 1959

YORUBA POETRY, ed. by Ulli Beier, Cambridge University Press, London, 1970